REMARKABLE
OREGON
WOMEN

REVOLUTIONARIES & VISIONARIES

Jennifer Chambers

THE
History
PRESS

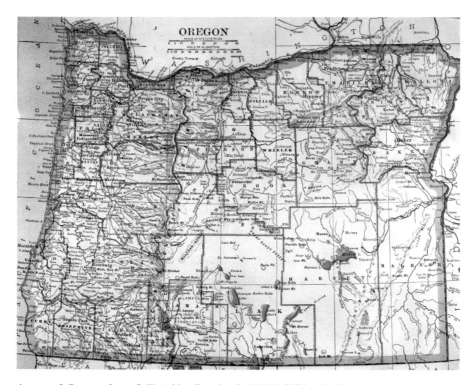

A map of Oregon from *Collier's New Encyclopedia* (1921). *Wikimedia Commons.*

This book is for my children, that they may know the accomplishments of these amazing women and be inspired to do their best in whatever is their passion. Changing the world can be as simple as changing your perspective if you work hard at it. Know that persistence pays off. Thanks for being with me when I work early in the morning, too.
As always, I am grateful for and amazed by the love and support of my husband, who makes my work possible.

Published by The History Press
Charleston, SC
www.historypress.net

CONTENTS

ACKNOWLEDGEMENTS

I have had great assistance from the Oregon Historical Society, especially Elena Alvorado and Scott Rook; thank you for your time and work in assisting me with the fine photographs herein.

Thanks to Rhonda Chambers for the use of her photo of Opal Whiteley's mural.

Pat Edwards is a partner in business and a great person to have on your side. Thanks, Pat.

Nancy Parrish and Jana Churchwell, many thanks for your assistance with Hazel Lee. Your work was very helpful, and I'm grateful for it. The help of Caroline D. Wilson from the Pentagon in researching Hazel Lee was also invaluable (and what fun to get e-mails from the actual Department of Defense!).

Thanks to Katie Meakins for her service and for the inspiration to find out more about Hazel Lee.

Thanks to my commissioning editor, Christen Thompson, for her help and support and to everyone at The History Press.

INTRODUCTION

I wanted to write about these women because Oregon has had so many women worth remembering. We are supposed to learn from history so we do not repeat its mistakes, true, but part of researching the influential people of the past is learning about the way they have created social and political change and changed the way we relate to the human condition. There is a quote by Ralph Waldo Emerson that puts it well:

> *Man is a bundle of relations, a knot of roots,*
> *whose flower and fruitage is the world.*

Another quote I kept in mind was by Opal Whiteley, who is featured in this book. She wrote about simple pleasures that get to the heart of what it is to be alive. Her work, though child-like, is beautiful. I'd like to think that each of these women had cause to feel a similar way about something that was dear to them at some point in their lives: "By the wood-shed is a brook. It goes singing on. Its joy-song does sing in my heart."

These women faced opposition from their society, from their families, from the world. They faced it by virtue of their sex sometimes or by political oppression or through poverty. The fact that so many of them were successful and managed to create things that lasted beyond their sphere really is remarkable.

I've had a lot of joy myself living with these women as I researched them. My goal was twofold: to celebrate their accomplishments and to present

those in as unbiased a way as I could so that the reader can draw her own inferences and perhaps take part of them into her own life. Learning more about and trying to represent even a portion of the women who influence Oregon as it is today has made me more aware of my own privilege. It's important to recognize how hard the women who came before me worked to make things better for all people. It has heightened the importance to teach my own children the idea that they, too, can question the status quo and propose change.

These are brief sketches of the women and are compiled to the best of my ability from a variety of reputable sources. I encourage the reader to follow up on any that interest you, as some of the subjects have longer, full-length works written about them, especially Julia Ruutilia (*Sticking to the Union* by Sandy Polishuk) and Beatrice Morrow Cannady (*A Force for Change: Beatrice Morrow Cannady and the Struggle for Civil Rights in Oregon* by Kimberly Mangun).

Remarkable women have made their mark on Oregon. They were not all born in Oregon, but they have impacted life here to such a degree that they have a place in our history. It makes sense that many of these women are not from the state originally, as Oregon, like the rest of the West, is an emigrant place, somewhere that is a destination rather than an origination point. More so, they are valuable to recall in times of struggle.

Enjoy their stories. Take them with you and see how you can impact your world.

NATIVE WOMEN, FIRST WOMEN

MARIE DORION AND SARAH WINNEMUCCA

These Indian baskets along the wall here are old. That is an old Indian cooking basket; it would hold water if it were soaked up. See the little designs on it, they all mean something, but I don't know what. The beads in this basket are some my father secured after the big flood of the Willamette in 1861, when a lot of Indian graves were washed out. Some of these are Hudson Bay Company beads, the kind they traded to the Indians for furs, and some of them—the dark blue ones I think—are beads said to have been used in trading by Lewis and Clark. The basket is full, you see, of many sorts of 2 necklets, etc., said to have been used at a very early day by various fur traders and early explorers. Father had them all labelled once, but they are all mixed up now. Someday, maybe, I'll find somebody who knows something about them and can straighten them out. Yes, it's too bad to have their history lost.
—Miss Mertie Stevens[1]

I t is an undeniable fact that the lives of Native Americans, or First Peoples, were inexorably changed when white settlers descended on and settled the West. Oregon was not unusual in its basic ignorance of native custom or ownership of land. The fact was the settlers entered a land inhabited by generations of people who were already there. Making a generalization about the women who lived in this area is difficult. All had their own beliefs, social systems and political and cultural customs. Females were, and remain, important and valued in the Native American culture of Oregon. Some, like Sarah Winnemucca and Marie Dorion, aren't as well known as Sacagawea,

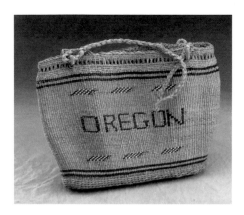

A Siletz purse, 1920. *Oregon Historical Society.*

but their contributions have been extremely important.

Oregon Territory was home to over eighty diverse groups of native tribes, as measured by Lewis and Clark on their first journey here in 1805 and 1806, with over thirty different languages. The Oregon Blue Book estimates that humans have been present in this area for "at least 10,000 years, and perhaps for another 5,000 to 10,000 years before that." The distinct ecosystems of the Coast Range, with its lush, wet seascapes, remained largely unaffected by the Spanish occupation of California territory, as it was accessible mainly by sea. The tribes in the interior were influenced more when the horse was introduced a generation before. Most of the interaction with natives and Europeans was through the Columbia River region and the fur trade that centered in Astoria. In the middle of the 1800s, the dispersion of tribes via disease lessened and was replaced by removal to centrally located reservations. The makeup of tribal groups shifted, but the First People continue to have a great impact on the culture, environment and even physical locations in Oregon.[2]

To understand the rapid demise of the native population, consider the Tillamooks. They were believed by some to be one of the most powerful tribes on the northern coast. A town, a bay, a cape and a county in the northwestern part of the state are all called Tillamook. Lewis and Clark counted 2,200 Tillamooks when they took note in 1805. In 1845, the Wilkes Exploring Expedition related only 400 members. By 1849, the tribe had shrunk to 200. A census report in 1910 gives their number as 25. The 1930 census could only claim 12.

As of 2015, there are nine federally recognized Native American tribes in Oregon:

- Burns Paiute tribe
- Confederated Tribes of Warm Springs
- Confederated Tribes of Coos, Lower Umpqua and Siuslaw
- Coquille Indian tribe
- Confederated Tribes of Grande Ronde
- Cow Creek band of Umpqua Indians

- Confederated Tribes of Siletz
- Klamath tribes
- Confederated Tribes of the Umatilla

Many tribes had subsets or bands of the same number who lived in neighboring villages, according to genealogical reports. While the tribes may have shifted according to the tribal warfare and social influx of whites and others, native Oregonians used the land efficiently. Sex roles played a part in tribal community, but women's roles in native tribes[3] in general differed by the location, culture and whether they were born into their tribe. In some tribes, like the Chinook, the first tribe that Lewis and Clark met peacefully in 1805, a male was always chief but a clan could be led by a man or a woman. The Cowlitz tribe was known for the intricate baskets woven by the women from cedar root and bark, dyed by each crafter from her own supply of alder and cherry and made from her designated basket tree. These cone-shaped baskets were quite valuable and often used for bartering.[4]

Women could fulfill a gatherer role, or some, such as females in the Spokane tribe to the north, were female warriors. Portraits like Paul Kane's *Scalp Dance*,[5] which depicts warriors holding a scalp aloft in the middle of a circle, were stylized representations of the fear that Indians caused in the hearts of the pioneers. Some women, like Anna Kash Kash and Edna Kash Kash, had portraits taken as members of the Cayuse by Lee Moorhouse as he documented their lives. They are now stored in the Smithsonian in Washington, D.C., where they can be seen as superb examples of Native American life in 1900. In a lecture series in 1936, Annette and Walter McClintock used a slideshow to detail the life and emphasize the scalping and war practices of the Blackfeet Indians, a tribe in Montana. This was not uncommon. These kinds of depictions both romanticized the female in native culture and contributed to the "evil native" narrative that served to frighten pioneers.

Those on the plateau used the waters and the resources of the tributaries of the mighty Columbia. The Owyhee, Grande Ronde, Umatilla, Snake, Deschutes and John Day Rivers were sources of commerce, trade, food and travel. This area includes the famed Celilo Falls area, or "Wy-Am," fished traditionally by the Columbia River Indian tribes in what is one of the most occupied sites on the continent. The people protested to hold on to their cultural tradition when the United States government flooded the falls area to create a dam on March 10, 1957.[6] The salmon culture of the native tribes in the area still makes fishing a large part of their livelihood and cultural identity, including things like the "First Salmon" ceremony, which honors the

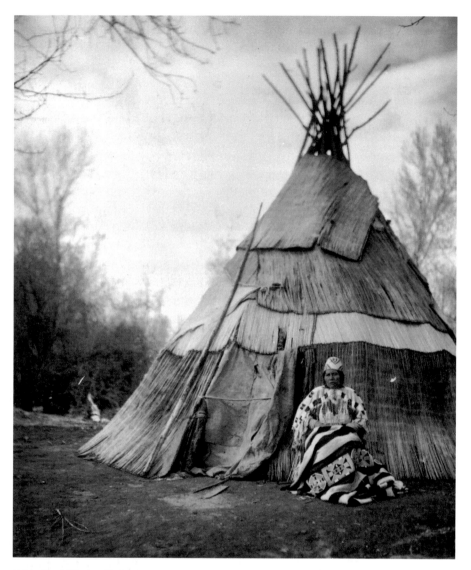

Edna Kash Kash. *Library of Congress Prints and Photographs Division, Washington, D.C.*

fish as an important part of tribal religion. Umatilla elders teach the young women of the tribe the art of edible root digging, an arduous three-day task performed while hiking through the Blue Mountains near Lexington, Oregon, so they can prepare a traditional feast for up to 350 people.[7]

The Great Basin people, like the Northern Paiutes, traveled up to two hundred miles in the harsh High Desert conditions. They made their homes

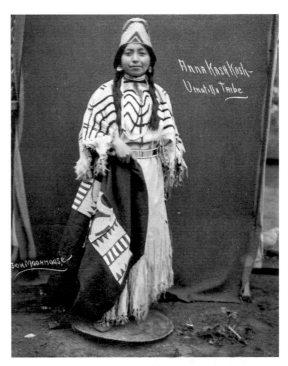

Right: Cayouse Anna Kash Kash was photographed by Major Lee Woodhouse on the Umatilla Reservation in the 1890s. *Oregon Historical Society*.

Below: "A Scalp Dance" slide, Annette and William Mc Clintock, 1938. *Yale University*.

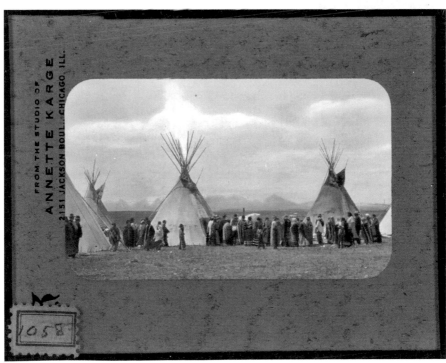

in movable lodges topped by tule mats and caves in mountainsides. The Warm Springs area—now an amalgam of the Wasco, Warm Springs and Paiute tribes—goes from the cascades to the Deschutes River. The Warm Springs tribes are a fishing culture and are also known for wood carving, basketry and beadwork.

The Chinook people, of whom the Multnomahs, Clackamas and Clatsops were part, lived along the Pacific coast area from Oregon to Washington without a federally recognized reservation in generally stable areas rather than moving around nomadically. They were recognized as accomplished hunters and fishermen who were known for their canoes. Lewis and Clark, in 1805, liked their canoes so much that upon finding they could not buy one as they were traveling home, they stole one. It was formally "replaced" in 2011 by a seventh-generation Clark family member. Females shared in the other duties but were generally also responsible for the care of the homes, which were large, bark-topped lodges; food; and the young. One interesting trait of this tribe is the tradition of pressing infants' skulls with boards from about three months to one year. This created a flattened skull that served as part of their complicated social caste system. The Chinooks were a tribe who sometimes took slaves among their captives, and "roundheads" were

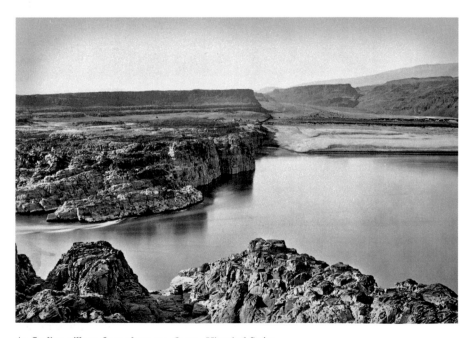

An Indian village from the pass. *Oregon Historical Society*.

easily identified as servants. Additionally, those with flattened skulls would generally not enslave others with flattened skulls. Land that was promised to the tribes was not delivered, and the Chinook tribe is still trying to own a piece of its aboriginal territory.[8]

The pioneers, then, came to a world already inhabited with people, culture, customs and a way of life that was utterly foreign to them. Progression is hard to stop, however, and many natives were involved in peaceful trades with the incomers at first. Examples of aggression on the part of Native Americans, like the Rogue River Wars, could be construed as aggression on the part of whites first by using the donation land and mining for gold to decimate the traditional land, crop and game so that starving indigenous people were virtually exterminated and then finalized when the government sent in troops in the late 1850s.[9] It's hard not to judge the pioneers by the standards we live in today, but we are lucky that parts of the First People's culture are present in Oregon in the names of our rivers and towns and in the tribes still present here.

The roles that native women filled were many, according to Indians.org, a popular website dedicated to serving Native American tribes and sharing their culture: "They were more than just mothers of the tribes' children. They were builders, warriors, farmers, and craftswomen. Their strength was essential to the survival of the tribes."

A woman called Marie Dorion, born in 1786 and once known as the "Madonna of the Oregon Trail," is responsible in large part for shaping Oregon into what it is today. She was also known as Wihmunkewakan, or "Walks Far Woman." As a contemporary of Sacagawea, she is much lesser known. Indeed, the two lived in St. Louis at the same time, but no historical documents can say if they ever encountered each other. In his book *Astoria*, Peter Stark surmises that they may have met, seeing as they were both native women living in St. Louis, both wives of interpreters and both involved in the fur trade. Marie was twenty-one when she crossed the continent in 1811–12 as part of John Jacob Astor's party to the mouth of the Columbia River, six years after Sacagawea crossed with Lewis and Clark. Astor, as a rich businessman, wished to monopolize the fur trade out of the area. His success is evident by the fact that the town remains in his name.

Marie's trial during the crossing was severe. She endured near-starvation, deaths of family members and being lost in the wilderness to save her children and help guide the way to Oregon country.[10] Half French Canadian and half Iowa Indian, Marie became the common-law wife of Pierre Dorion in 1804. Dorion, half Sioux Indian through his mother, was

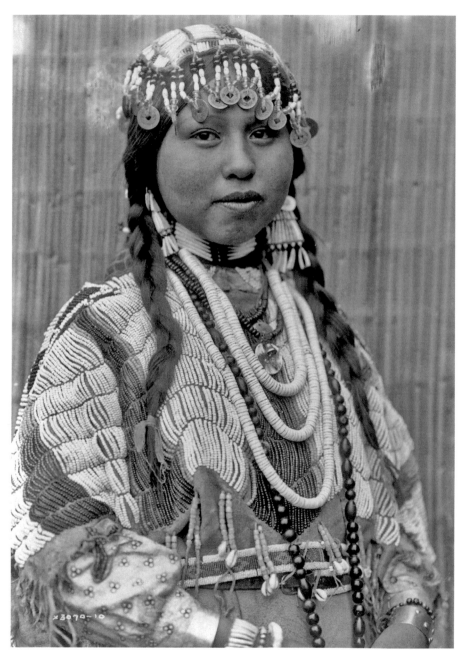

A Wishram bride in 1910. *Library of Congress Prints and Photographs Division, Washington, D.C.*

fathered by a French Canadian man who had been part of the Lewis and Clark party. The Dorions moved to St. Louis in 1810 after the births of their two boys, Jean Baptiste and Paul, and were contacted there by the Pacific Fur Company.

William Price Hunt, who worked for the company, recruited Pierre Dorion as a guide, interpreter and hunter for his expedition that was funded by Astoria. There were some reservations about Pierre's temper and stubborn nature. In the end, Hunt was forced to take on Marie and her children as part and parcel of Pierre's services. Indeed, a few times early in the trip, Pierre was violent with Marie when he was drinking, to the point where she left the trip until he was sober. Pierre's fondness for alcohol is described by Washington Irving in his 1836 book, *Astoria*:

> *It was his love of liquor which had embroiled him with the Missouri Company. While in their service at Fort Mandan, on the frontier, he had been seized with a whiskey mania; and, as the beverage was only to be procured at the company's store, it had been charged in his account at the rate of ten dollars a quart. This item had ever remained unsettled, and a matter of furious dispute, the mere mention of which was sufficient to put him in a passion.* [11]

Marie's decision to leave the party did not go unnoticed, as reported by Irving: "He was gladly taken on board, but he came without his squaw. They had quarreled in the night; Pierre had administered the Indian discipline of the cudgel, whereupon she had taken to the woods, with their children and all their worldly goods."

Nevertheless, she rejoined him shortly thereafter, calling out to him on the morning of the next day from across the river. Marie found she was pregnant while on the journey and was charged with the care of her children as well, probably two and four years old at the time. They forded rivers and traversed mountains, valleys and buttes. It must have seemed like countless obstacles were in the way. At the Snake River, it was thought that making canoes and floating down the Idaho River would save time. The flimsy cottonwood canoes shivered in the raging waters and tossed supplies in the river, and two of the party drowned. The remaining members were forced to walk.

Some relief for the ever-more-pregnant Marie would come in the form of a horse. Pierre traded a buffalo robe for the horse and refused to let the party slaughter it even when food and wildlife grew limited. She gave birth

to her child with not much to say from Pierre, according to Irving, whose account is relatively contemporary. It was an "occurrence that could be arranged and need cause no delay." The others of the Astor party made their way to an Indian village and rested. Marie, Pierre and their family joined them a day later, Marie having ridden twenty miles a day after giving birth. The baby died within a few days, unfortunately, and was buried near North Powder, Oregon. It was the first child with any white blood born in Oregon country.

The party toiled on until it reached what would become Fort Astoria. Marie and Pierre Dorion and family returned to the Snake River area for a time. Then comes the most amazing part of her story. She was preparing a meal at a Pacific Fur Company trading post one evening in January 1814 while her husband was out with a small party trapping animals. A scout came in bearing alarming news: Pierre and the trappers were about to be attacked by a group of Bannock Indians that had already done the same to another camp that morning.

Marie went on a three-day trip with her children to warn the men. When she arrived, she met a terrible sight. The camp had already been attacked. Pierre was dead. LeClerc, a fellow trapper, was barely alive, and she rescued him and led him away on a horse to nurse him back to health. Despite her care, LeClerc died on the first night, and she and her children set off to find help at the main trapping camp. It was not to be. They discovered upon arrival that the camp had also been ambushed and the inhabitants killed and scalped.

With little options available to her, Dorion loaded her children and some supplies on the horses and rode west toward Oregon Territory to try to find assistance. It was bitterly cold. Ice and snowy conditions echoed the first time she had crossed the Snake River and environs. At the foot of the Blue Mountains, she had to choose. Would it be more advantageous to make camp and wait out the worst of the weather or press on? Some of her choice must have been made when one of the horses died. She made camp and smoked the horse meat, foraged for frozen berries and fed herself and her children on that plus what she could harvest in fauna and wildlife in the area. The party remained in camp until the snow started to melt, some months later, and then set out. The weather changed almost immediately and snowed them in again, and they were forced to make camp until they could travel safely without risk of "snow blindness."

Some fifteen days after they broke their winter camp, the family reached the Walla Walla tribe on the Columbia River. Interestingly, the Pacific Fur Company reached the area shortly thereafter on a trip upriver to find the

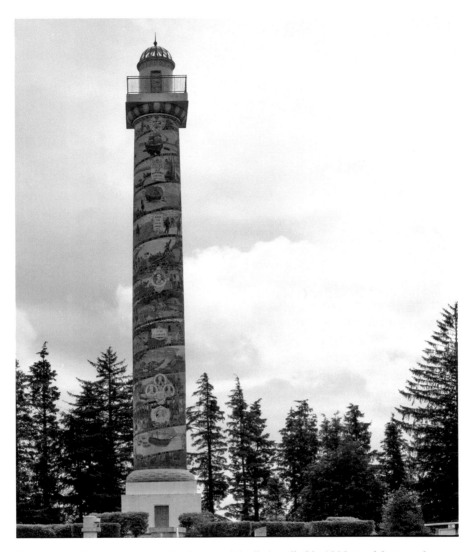

The Astoria Column as seen today. It was originally installed in 1926 to celebrate early Astoria settlers. *Carol M. Highsmith Archive, Library of Congress, Prints and Photographs Division, Washington, D.C.*

Idaho trapping team. All were astonished to hear of Dorion's survival amid the turmoil and slaughter she had endured. From traveling cross-country, mainly on foot, pregnant with two toddlers, to literally saving her family from starvation, her story must have seemed a work of fiction. These words of Irving were written about simply the Astoria trip, but they could be taken for her entire perilous journey: "Indeed on various occasions in the course

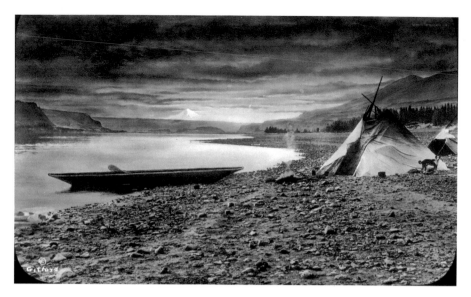

The Columbia River. *Oregon Historical Society.*

of this enterprise, she displayed a force of character that won the respect and applause of the white men."

Her force of character must have been as immense as her courage. Dorion would go on to live in Oregon Territory and moved to the French Prairie. She married two more times and had three more children. Her son Jean-Baptiste was in a rifleman in the Cayuse War (1847–50). With her third husband, she moved close to what is now Salem, Oregon, and became a devout Catholic. She died at approximately sixty-four and was buried with honor beneath the St. Louis Catholic Church in 1850.

Dorion is so influential in parts of the Pacific Northwest that a Madame Dorion Memorial Park is named for her in Walla Walla, Washington. A dormitory at Eastern Oregon State College is named after her. A plaque in her honor is placed at the Vista House, a magnificent overlook on the mouth of the Columbia River in Oregon. The plaque states:

> *Dedicated to the memory of Marie Dorion.*
> *Red Heroine of the West.*
> *Wife of Pierre Dorion.*
> *Interpreter with Astoria Overland Expedition from St. Louis to the mouth of the Columbia, under the leadership of Wilson Price Hunt. That party passed this point early in 1812.*

Erected by the Oregon Society, Daughters of the American Revolution, March 1, 1941.

One of the modern commentaries on her life comes from a piece published on the National Women's History Museum, which stated, "Because Marie lived by a different moral code, she bore two children, Francois and Marianne, prior to their belated 1841 marriage. The mother of five children by three men, she had learned independence early in life." Her independence, integral as a source of strength, is almost an understatement. Her accomplishments and bravery are commendable by any standard, let alone a standard based on European modern-day marriage traditions. She was the second woman to travel west in the exploration of half of the United States. She conquered 3,500 miles and kept her children alive through it all. The nickname "Madonna of the Oregon Trail" is well earned.[12]

Sarah Winnemucca was also not born in Oregon but had great influence here. Her 1883 biography, *Life Among the Paiutes: Their Wrongs and Claims*, is said to be the first book written by an "Indian...West of the Rockies." As a negotiator, she helped mediate between native culture and the U.S. Army in the Bannock Wars and was successful in her peaceful aim, for the most part. Unfortunately, she was not as successful in securing rights as in preserving her way of life though her writing. The work is a well-preserved slice of what life was like for the native and white cultures of the first forty years that they were entwined. Her book begins: "I was born somewhere near 1844, but am not sure of the precise time. I was a very small child when the first white people came into our country. They came like a lion, yes, like a roaring lion, and have continued so ever since, and I have never forgotten their first coming."[13]

The meeting with the white people would be an unfortunate one. Her grandfather, who looked forward to meeting them, was betrayed, and the tribe's entire winter food supply was burned to the ground. She wrote that her grandfather foresaw the white means of communication revolutionizing both peoples and spoke in wonder of the "rag-man" who could spread messages through the use of paper far more widely and efficiently than in an oral tradition. His enthusiasm for the medium was accurate in recognizing that it was a means that would change their lives in dramatic ways.

One of Winnemucca's important legacies is in advocating for the rights of natives to speak their language. She started the first school in the West where families could speak their mother tongue. A member of the Northern

Paiute tribe, a band of around 150, she traveled from her home area north to the Malhuer Valley in southeast Oregon. She had a facility for language that would serve her as an interpreter. The Nevada Women's History Project states that "by the time she was fourteen, she had acquired five languages, three Indian dialects, English and Spanish."[14] Her history as the daughter of two chiefs perhaps gave her the confidence to speak so eloquently in defense of the culture in which she lived. Her original name was Thocmetony, which translates as "shell flower." She writes about her name here in a vignette of her cultural tradition:

> *Many years ago, when my people were happier than they are now, they used to celebrate the Festival of Flowers in the spring…Oh, with what eagerness we girls used to watch every spring for the time when we could meet with our hearts' delight, the young men, whom in civilized life you call beaux. We would all go in company to see if the flowers we were named for were yet in bloom, for almost all the girls were named for flowers…All the girls who have flower-names dance along together, and those who have not go together also.*
>
> *I will repeat what we say of ourselves. "I, Sarah Winnemucca, am a shell-flower, such as I wear on my dress. My name is Thocmetony. I am so beautiful! Who will come and dance with me while I am so beautiful? Oh, come and be happy with me! I shall be beautiful while the earth lasts. Somebody will always admire me; and who will come and be happy with me in the Spirit-land? I shall be beautiful forever there. Yes, I shall be more beautiful than my shell-flower, my Thocmetony! Then, come, oh come, and dance and be happy with me!" The young men sing with us as they dance beside us.*[15]

She lived with and among her people until about age sixteen. Her grandfather, Chief Truckee, facilitated her and her sister's education among whites in a convent school for a time. He had been a guide to Captain John C. Frémont across the Great Basin area and won praise as a fighter in the Mexican-American War. She continued to learn as she and her family were moved and their tribal land was being swallowed up.

They were moved to the Pyramid Lake Reservation in Nevada. While the tribal agent, Samuel B. Parrish, was in charge, things were mainly peaceful on the reservation. Crops were planted, and a school was opened at which Winnemucca worked. When a new tribal agent, William V. Reinhart, took over, conditions worsened as the agent withheld pay and did things like sell the supplies destined for Paiutes to white people instead.

An Indian girl in sunshine. Photo by Lee Woodhouse, 1900. *Library of Congress Prints and Photographs Division, Washington, D.C.*

The Pyramid Lake War claimed the lives of many family members in 1860, the same year the girls were asked to leave the convent school because "parents of the White students objected," according to Winnemucca biographer Kelly Sassi. That same year, her grandfather Truckee died of a tarantula bite. Although each tribal male was promised 160 acres of the Pyramid Lake area's land, it was unusable. After the war, Winnemucca became acting chief of her part of the tribe at age twenty-one. The tribe complained to the government, through Winnemucca, of the harsh treatment they had received and how the treaty was not being honored by the quality of the land they had been forced to swap for. They eventually requested shelter in Fort McDermitt from the Nevada Volunteers, who had made it their mission to raid the tribe and remind them who was in charge in various raids and attacks.

After a failed marriage, Winnemucca moved with her people to the Malheur Reservation in Oregon, where she successfully fought to change her name back to Winnemucca. The tribe was finally moved to the Yakima, Washington reservation by 1814. She met some resistance by her tribe, who claimed that she was trying too hard to assimilate. Some critics of her biography also note her viewpoint is suspect for being too Christian and influenced by her time spent in nonnative culture. Karen Kilcup, of the University of North Carolina–Greensboro, writes about the hard spot Winnemucca was in with both her people and the whites of the time:

> *Negotiating between two worlds was never easy, and Sarah was often placed in a precarious position with her own people by the false promises of white officials as well as by her own goal of assimilation. Her difficulties were also intensified by gender. A favorite claim of her detractors—and one leveled at many women reformers of the time—was that she was promiscuous. This charge is ironic in view of the sexual abuse of Indian women by white men that Winnemucca describes in the section in the book, abuse so prevalent and unrelenting that she affirms, "the mothers are afraid to have more children, for fear they shall have daughters, who are not safe even in their mother's presence." At least two of the wars that Sarah describes in her book were initiated by such abuse.*[16]

She traveled across the country to make the public aware of the mistreatment of her people at the hands of the government. In 1878, when she assisted with the Bannock War by interpreting between troops and Bannock fighters, she was able to intervene in a situation where her

father was held hostage by an enemy tribe. Her rush to her father's aid was a one- to two-hundred-mile trip over rough Idaho and Oregon Territory, and to do it Winnemucca went without sleep for almost forty-eight hours. Her assistance in the Bannock War negotiations gave her renewed respect in the eyes of some tribal members.

Though she traveled great distances at no small risk to herself, her visit with the president and Senate of the time did not have the desired effect. She asked Carl Shurz, secretary of the interior at the time, if he would give them back their homelands, but to no avail. Her meeting with President Rutherford B. Hayes extracted promises to return her people to their Malhuer Reservation land that were ultimately empty, and the order to do so was never executed.

After a stint as a teacher, Winnemucca married L.H. Hopkins, who was an army officer. The "Princess," as she was sometimes known, went on an extensive eastern United States lecture tour to raise support and money for her cause. The decision to write a book to more widely illustrate her ideas came in the early 1880s, and it was published in 1883. She was assisted in her work by the wife of the educator Horace Mann, as well as her sister. She published a pamphlet, *Sarah Winnemucca's Practical Solution to the Indian Problem*, in 1886, with the sponsorship of Elizabeth Peabody, who helped start the school Winnemucca founded. Pamphlet sales went to support this endeavor.

Her lecture tour made it possible to collect thousands of signatures in support of giving the Paiutes back their land, and Congress passed a bill to make that happen in 1884. It was never fulfilled. Winnemucca taught at a school for Paiutes in Nevada from 1883 to 1886. After her husband passed away in 1886, her own health declined, and she died in October 1891.

She had proved the prophetic words of her grandfather right, however. The paper that brought change for her people made it possible for her to fight for and preserve part of her culture. At the same time, worthless "rags," like the ones the false treaties with the U.S. government were written on, made an incredible impact on her tribe and her people. She must have felt always torn, caught as she was between cultures and in the midst of a great change in the country. Her work remains preserved as a snapshot of a people, a time and a place unique to America.

Modern-day activists bring awareness to native causes. Along with the people bringing back fishing rights to Celilo Falls, traditional hunting rights are being granted to tribes in certain areas today after long-fought discourses. Tribal members like Warm Springs member Alyssa Macy represent their people at events like the United Nations World Conference on Indigenous

Peoples to talk about the preponderance of sexual assault among Native Americans. In an article in the *Bend Weekly* newspaper in 2015, Macy is quoted as saying, "The research shows that Native women are victims of sexual crimes at extraordinarily high rates, and we're talking three out of five women have been assaulted in their lifetime. I can sit down with my group of friends that are Native and every single one of them has been sexually assaulted, raped, or experienced some kind of molestation as a child, and I think that's really devastating to Native communities."[17]

Work like Macy's is vital in the community. The Violence Against Women Act, when it was renewed in 2013, allowed sexual and domestic assault against natives by both nonnatives and natives to be prosecuted. It made it possible for three tribes in Oregon to have jurisdiction when violent crimes occurred. As "Native women are 10 times more likely to be murdered," according to the *Bend Weekly* article, these kind of statistics are a startling reminder of the work that is still to be done to help native people.

The poverty that Native Americans endure in Oregon echoes that of the United States. The 3 percent of Oregon's population that self-identifies as native is part of the highest rate of any race group to live in poverty. Shockingly, 33 percent of natives in the country live at or below the poverty line, as opposed to 12 percent of whites in the 2012 study by the National Center for Educational Statistics. Educational opportunity is rising nationally among native populations, however, and nationally, 41 percent of female natives in 2004 started a four-year college and graduated within six years.[18]

Groups like the International Council of Thirteen Indigenous Grandmothers have roots in Oregon. This band of women is committed to a lifetime of prayer and action in support of peace and conservation of the environment, as well as communication and advocacy between peoples. The women are from all over the earth and represent their values as leaders. Watching them speak is like merging the past and the present simultaneously. Grandmother Agnes Baker Pilgrim, at eighty-four the oldest living Takelma Siletz from Grants Pass, Oregon, says in her mission statement:

> *We grandmothers have come from far and wide to speak of the knowledge we hold inside. In many languages we have told it is time to make the right changes for our families, for the lands we love. We can be a voice for the voiceless. We are at the threshold. We are going to see change. If we can create the vision in our heart, it will spread. As bringers of light, we have no choice but to join together. As women of wisdom we cannot be divided. When the condor meets the eagle—thunderbirds come home.*[19]

father was held hostage by an enemy tribe. Her rush to her father's aid was a one- to two-hundred-mile trip over rough Idaho and Oregon Territory, and to do it Winnemucca went without sleep for almost forty-eight hours. Her assistance in the Bannock War negotiations gave her renewed respect in the eyes of some tribal members.

Though she traveled great distances at no small risk to herself, her visit with the president and Senate of the time did not have the desired effect. She asked Carl Shurz, secretary of the interior at the time, if he would give them back their homelands, but to no avail. Her meeting with President Rutherford B. Hayes extracted promises to return her people to their Malhuer Reservation land that were ultimately empty, and the order to do so was never executed.

After a stint as a teacher, Winnemucca married L.H. Hopkins, who was an army officer. The "Princess," as she was sometimes known, went on an extensive eastern United States lecture tour to raise support and money for her cause. The decision to write a book to more widely illustrate her ideas came in the early 1880s, and it was published in 1883. She was assisted in her work by the wife of the educator Horace Mann, as well as her sister. She published a pamphlet, *Sarah Winnemucca's Practical Solution to the Indian Problem*, in 1886, with the sponsorship of Elizabeth Peabody, who helped start the school Winnemucca founded. Pamphlet sales went to support this endeavor.

Her lecture tour made it possible to collect thousands of signatures in support of giving the Paiutes back their land, and Congress passed a bill to make that happen in 1884. It was never fulfilled. Winnemucca taught at a school for Paiutes in Nevada from 1883 to 1886. After her husband passed away in 1886, her own health declined, and she died in October 1891.

She had proved the prophetic words of her grandfather right, however. The paper that brought change for her people made it possible for her to fight for and preserve part of her culture. At the same time, worthless "rags," like the ones the false treaties with the U.S. government were written on, made an incredible impact on her tribe and her people. She must have felt always torn, caught as she was between cultures and in the midst of a great change in the country. Her work remains preserved as a snapshot of a people, a time and a place unique to America.

Modern-day activists bring awareness to native causes. Along with the people bringing back fishing rights to Celilo Falls, traditional hunting rights are being granted to tribes in certain areas today after long-fought discourses. Tribal members like Warm Springs member Alyssa Macy represent their people at events like the United Nations World Conference on Indigenous

Peoples to talk about the preponderance of sexual assault among Native Americans. In an article in the *Bend Weekly* newspaper in 2015, Macy is quoted as saying, "The research shows that Native women are victims of sexual crimes at extraordinarily high rates, and we're talking three out of five women have been assaulted in their lifetime. I can sit down with my group of friends that are Native and every single one of them has been sexually assaulted, raped, or experienced some kind of molestation as a child, and I think that's really devastating to Native communities."[17]

Work like Macy's is vital in the community. The Violence Against Women Act, when it was renewed in 2013, allowed sexual and domestic assault against natives by both nonnatives and natives to be prosecuted. It made it possible for three tribes in Oregon to have jurisdiction when violent crimes occurred. As "Native women are 10 times more likely to be murdered," according to the *Bend Weekly* article, these kind of statistics are a startling reminder of the work that is still to be done to help native people.

The poverty that Native Americans endure in Oregon echoes that of the United States. The 3 percent of Oregon's population that self-identifies as native is part of the highest rate of any race group to live in poverty. Shockingly, 33 percent of natives in the country live at or below the poverty line, as opposed to 12 percent of whites in the 2012 study by the National Center for Educational Statistics. Educational opportunity is rising nationally among native populations, however, and nationally, 41 percent of female natives in 2004 started a four-year college and graduated within six years.[18]

Groups like the International Council of Thirteen Indigenous Grandmothers have roots in Oregon. This band of women is committed to a lifetime of prayer and action in support of peace and conservation of the environment, as well as communication and advocacy between peoples. The women are from all over the earth and represent their values as leaders. Watching them speak is like merging the past and the present simultaneously. Grandmother Agnes Baker Pilgrim, at eighty-four the oldest living Takelma Siletz from Grants Pass, Oregon, says in her mission statement:

> *We grandmothers have come from far and wide to speak of the knowledge we hold inside. In many languages we have told it is time to make the right changes for our families, for the lands we love. We can be a voice for the voiceless. We are at the threshold. We are going to see change. If we can create the vision in our heart, it will spread. As bringers of light, we have no choice but to join together. As women of wisdom we cannot be divided. When the condor meets the eagle—thunderbirds come home.*[19]

Kathryn Jones Harrison, a leader in the Grande Ronde tribe, was part of an abusive foster family after her parents died in 1934, when she was ten years old. An article in *1859 Magazine*—a publication described as writings "into the soul of Oregon"—details her upbringing as one "that tried to purge her Indian heritage."[20] Instead, she became an activist who championed the Tribes of Grand Siletz and the Tribes of the Grande Ronde on separate occasions to achieve federal recognition and worked on the Reservation Restoration Act of 1988 with Governor Barbara Roberts and Senator Mark O. Hatfield. She was elected to the Tribal Council and stayed there for twenty-two years, winning numerous awards. With her help, the Spirit Mountain Casino was started in 1997. The charitable arm of the casino has given about $45 million to nonprofits since its inception.

Native women are visible in Oregon communities in smaller ways as well. On August 4, 2015, a concrete memorial play structure was dedicated in Corvallis, Oregon, to the memory of Nigel Rose Weber, a seven-year-old member of the Grande Ronde tribe who died unexpectedly. The tribe erected the structure, cast to look like a traditional Kalapuya wooden sculpted bowl, in a local park. It was dedicated by tribal members, the mayor of Corvallis and Native American activist Winona LaDuke. Weber's mother had worked with LaDuke in her activism against the tar sands pipelines in the midwestern United States. The day after the dedication, the two rode horses along the route of the proposed pipeline to protest the oil project that may cause climate change.

The activism that the native women of today demonstrate is imperative in securing the important lessons of the history of the women and culture of the First Peoples for generations to come. These people, in different tribes and with myriad customs, are a big piece of Oregon history. That they can persist into a thriving and important future is vital. Recognizing the contributions of these peoples to Oregon culture is necessary and important, as without them we would not be here.

Chapter 2

PIONEER WOMEN

VOICES FROM THE OREGON TRAIL

I'm sure we've seen no picture, In the volumes anywhere, Of a tall, athletic woman, With long and streaming hair, Going out against the redskins, To save a fleeing son, And with her strong hand grasping Her husband's trusty gun.
—*Catherine A. Coburn, "Gist of Women in Pioneer Days"*[21]

These words come from a song sung by an anonymous pioneer poet, son of a pioneer mother, and are recorded by pioneer woman Catherine Coburn in her diary. The song, which one can imagine sung around the campfire in the middle of a ring of wagons, illustrates the tragic ordeal of his family's story and the heroism of his mother. The image of the pioneer mother was made larger than life in stories and song but was no less true in many real-life cases, as the women endured horrific circumstances and made do for their families with so much less than they were used to. The women were cooks, gardeners, housemaids, child-minders, laundresses, protectors, etc. Many were left alone while the men of the house worked elsewhere or hunted for game in the woods. In the case of the pioneer poet, his mother was at the house while his older brother and father were "on the range" when they were killed by local natives. He saw the event and ran back home to the "inch-board shanty" while the natives were chasing him. His mother held off any intruders with her husband's gun and sat watch for four days until help arrived. His song goes on: "And there of guard we found them, When four long days had fled, Half-crazed with sleepless watching And sorrow

for the dead, And still that faithful mother, When we came, a saving band, Stood by the open doorway, With the rifle in her hand."

His experience was not unique. Nor was the fervor and trepidation with which many pioneers greeted the Native Americans on the Oregon Trail. The new land they were crossing held many wonders that provoked what seemed an equal mixture of fear and awe. Harriet Scott Palmer wrote in a pamphlet about her experience crossing in 1852: "When we crossed into Nebraska, it seemed such a wide stretch of plain. We got our first sight of Indians—a file of Indians were passing along, single file. They were the Pottowattamies, dressed in buckskins, beads, and leading their ponies."

The herculean task set before the travelers on the Oregon Trail was borne by the family. Palmer writes that it took six months for her group to travel the road over the spring and summer of 1852. Eight months was not unheard of depending on weather. Preparations for the wagons and stock and the sale of homes and possessions alone took months. Pioneers lost loved ones on the trail. Palmer lost her mother and four-year-old brother to sickness before they reached Oregon Territory. We know this because she left a journal. These diaries are incredible resources for understanding what the women felt, did and saw during their months on the Oregon Trail. Women wrote by candlelight, the books balanced on their knees outdoors. They wrote as they tried to steady their hands in jostling wagons over nearly two thousand miles from Independence, Missouri, to Oregon. Fabulous journals and memories of the Oregon Trail and living among early Oregon Territory exist in the Library of Congress in Washington, D.C.

Bethenia Owens-Adair, profiled in chapter 10, was one of the travelers on the first official (and larger) Oregon Trail trips in 1843. The territory, though already populated by Native Americans at the time and clearly not "empty" land to be filled up by migrants, was ripe for settlement by missionaries like Marcus and Narcissa Whitman. Narcissa was the first female of European ancestry to cross the Rocky Mountains when she and Marcus traveled across the country in 1836. Narcissa was reported to have pursued Marcus after initial acquaintance because she could not join a missionary group as a single woman. After a mail correspondence, the pair was married. The two, along with two other couples, aimed to establish a ministry borne of their strong Protestant faith. When they arrived at the Walla Walla River area in southeast Oregon Territory, they decided to make the missionary there. The area is now on the border between Washington and Oregon but is an important marker on the Oregon Trail. One can see wagon tracks well preserved in the area, parallel ruts cut so deep that they are still visible almost 180 years later.

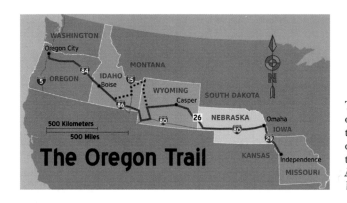

The 2,200-mile line of original emigration to the Pacific Northwest, commonly known as the Old Oregon Trail. *Map by Gorilla Jones via Wikimedia Commons.*

In his diary of the overland trip in 1836, Marcus Whitman wrote, "Wherever a wagon can go, a woman can go." He thought that when the women tired of riding horses, they could simply ride in the wagons. His theory, which skirted the reality a bit of how the trips actually went, had a point: women were and are capable of doing much the same as men. In modern times, we do not doubt that. But at the time, it was thought that white women were simply too fragile to travel so long and difficult a journey. Narcissa and her sister Eliza made it possible for families to cross the country. In doing so, and by writing about their experience, they changed our nation.

It was decided to start the mission to serve Cayuse Indian families. Marcus served as a doctor, and Narcissa served as a cultural advocate from the east and taught for the school located at the mission. Their view that the natives needed "saving" seems presumptuous now, but it was perfectly acceptable for the time and was, in fact, the tradition of conquering people throughout history from Rome onward. Narcissa wrote in a letter to her mother in 1840: "We feel that we cannot do our work too fast to save the Indian—the hunted, despised and unprotected Indian—from entire extinction."[22]

The Whitman couple, well intentioned but ill prepared for the reality of life in the West, lost their daughter in a tragic drowning after she went to get two cups of water from the river for a meal. Despondent, reports are that Narcissa would not let go of the child for four days after her death. It must have seemed like providence itself when later Mrs. Sager, whose husband died en route to Oregon, drove her wagon and children farther down the trail until she collapsed and died of a malaise called "camp fever" in Utah Territory. The seven Sager children, who stair-stepped in age from a few weeks old up to fourteen, went on with the wagon train and settled at the mission. They lived happily with the Whitmans until the Cayuse Indians attacked and killed fourteen people

in the mission, including two of the Sager children and both Narcissa and Marcus Whitman. Catherine Sager lived through the attack and went on to marry and have her own family. She was brave enough to write about her horrific experience. Imagine the pure bad luck that came from surviving such a journey only to lose more family in your place of rescue.

Illness, attacks and accidents affected more families than they did not. It was an accepted fact that some calamity might happen while on the trail. Part of what is so astonishing is that so many of them did keep going, moving with the train across bone-jarring roads, icy conditions and famine. The weather was a foe that many of them had not faced on that scale before. The rivers, storms, lightning, snow and heat all took a great toll on even the most prepared family.

The terrain caused any number of delays. Even the stoutest wagon was hard-pressed to make it the entire trip. Some of the more expensive wagons were made with the ability to float to more easily ford the rivers or streams. River crossings often meant tolls, especially if there was a raft to help get across. Amanda Stewart Knight wrote in her diary from 1853 about their trip through southern Oregon on the way to the fertile Willamette Valley: "Came 5 miles this morning, and are now crossing Fall (or Deschutes it is called here) River on a ferry boat. Pay three dollars a wagon and swim the stock. The river is very swift and full of rapids."

Contrary to the romanticized "heathens," as they were depicted by inflammatory literature and broadsides of the day, Native Americans were often helpful and astute businessmen. You can almost hear the women's assumptions about the people who shared their country changing as they wrote in their journals. Near the Snake River, Amelia Stewart Knight wrote:

> *Our worst trouble is getting the stock over. Often after swimming over half way over the poor things will turn and come out again. At this place, however, there are Indians who swim the river from morning until night. There is many a drove of cattle that could not be got over without their help. By paying them a small sum, they will take a horse by the bridle or halter and swim over with him.*

Nancy Hembree Snow Bogart wrote later in her life in a stream-of-consciousness way of the trail: "I've often been asked if we did not suffer with fear in those days but I've said no we did not have sense enough to realize our danger we just had the time of our lives but since I've grown

older and could realize the danger and the feelings of the mothers, I often wonder how they really lived through it all and retained their reason."[23]

Children faced the same starvation and harsh conditions as the adults but with less sense of boundaries or intuition. They would wander away. Some were caught in stampedes. Others were crushed beneath the wheels of the wagons. One family tells of a tragic event when the mother hung medicine in a bag on the side of the wagon. The little girl on the wagon train begged to taste the medicine, and the mother said no. When the mother was cooking dinner, she asked the children to come sit down. The little girl was sleepy, so she was told to go lie in the blankets. She never woke up. It was found that she had taken the medicine bag and drank an entire bottle of laudanum. Travelers could die from measles, dysentery or cholera. The miracle was how many made it.

Death was a constant companion, and travelers had to deal with it as best they could. In spots of the plain there were few places that could be easily dug up, and bodies had to be covered by rocks to keep out animals. A young girl who was dying of starvation and fever begged her family to dig her grave six feet deep and cover her up well with rocks so the wolves wouldn't get her. When she passed, the grave was dug, but her mother saw it was only four feet deep and jumped in the hole to complete it herself. There was no time or point to headstones. Catherine Haun relates the death of Mrs. Lenore, a Canadian woman in their group, in her journal:

> We waited a day to bury her and the infant that had lived but an hour, in this weird, lonely spot on God's footstool away, apparently, from everything and everybody. The bodies were wrapped together in a bed-comforter and around, quite mummified, with a few yards of string that we made by tying together torn strips of a cotton dress skirt. A passage of the Bible (my own) was read; a prayer offered and "Nearer My God to Thee" was sung. Owing to the unusual surroundings the ceremony was very impressive...
>
> There were no tombstones—why should there be—the poor husband and orphans could never hope to revisit the grave and to the world it is just one of the many hundreds that marked the trails of the Argonaut.

Travelers moving west passed Independence Rock in Wyoming, 1,900 feet long, 128 feet tall and 700 feet wide. A giant monolith appearing in relief across the horizon, it was a good stopping point. The gray granite landmark was a point of trail that migrants hoped to reach by midsummer, or Independence Day, in order to keep on schedule.[24] If arrival at the rock

was later than that, haste had to be made. The rock was a place to leave your mark, a bulletin board of sorts to show friends farther back on the trail that you had been there. It was called the "Great Register of the Desert" for the more than five thousand signatures carved on it. According to some reports, artisans set up shop and carved names into the rock for a small fee. That might account for the way some names look more precisely cut rather than scratched or chipped crudely into the face of the rock.

The women's sphere was not just that of home and hearth on the trail. The care given to daily tasks helped maintain the aura of normality that made each day bearable. A typical day while in the wagons started at 4:00 a.m., when the bugle sounded to wake everyone in camp. By 5:00 to 5:30 a.m., the women and children were up making breakfast, which consisted of bacon and cornmeal hot cereal or, if you were lucky, Johnny cakes, a pancake of sorts made from cornmeal and water and baked. By 6:00 a.m., dishes were done, and by 7:00 a.m., the wagons were ready to go. If all went as planned, they traveled until noon, when an hour-long rest and meal was taken, and by 5:00 p.m., they would stop for the night. Camp was made in the best circumstances where there was a place for the animals to graze and the wagons made a circle that was defensible. They ate and did chores from

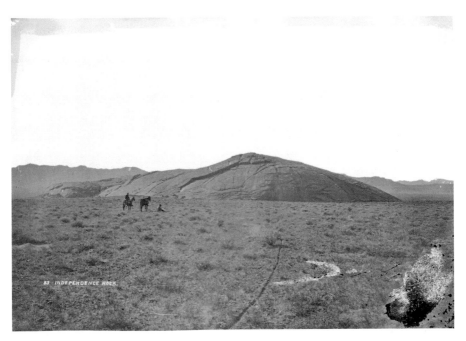

Independence Rock in 1870. *Photo by Department of the Interior. General Land Office. U.S. Geological and Geographic Survey of the Territories. Wikimedia Commons.*

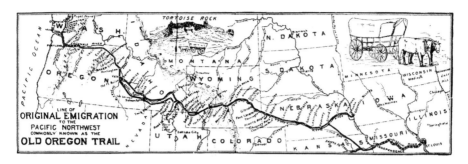

The Oregon Trail in 1907. *Oregon Historical Society.*

6:00 to 8:00 p.m. and then retired for the evening, except for those on night watch. Watch was changed at midnight. That was every day, being as flexible as necessary, for the duration of the trip. Progress was extremely important, and a good day was twenty miles or more.[25]

Sara Byrd, whose family crossed when she was five years old in 1848, recalls in an interview what it was like to live once you had crossed the trail and arrived in Oregon. Her interview was transcribed phonetically:

> *We went up the Skipanon River frum Astoria, wher father settled an a squatter's claim. It wuzn't surveyed then. They jest had squatter's claims. We jest camped at first, an' then father built a log cabin with shake roof, an' a fireplace made o' sticks an' mud. It hed a floor too, sort o' what you'd call a puncheon floor I guess—logs hewed flat on all sides an' put together. We'd brought two chairs across the plains thet father'd made in I-o-way. They hed cowhide seats in 'em. Later on, here in Oregon, he put rockers on 'em, an' they wuz al'ays father an' mother's chairs.*[26]

She and others wrote of how the traditional male and female jobs blurred in the new world and on the trail. Women had more part in men's tasks like pitching tents and helping with animals. A very few women, left on their own with families on the road, led their families most of the way across the trail. That relaxing of rules sometimes, but rarely, extended in a small aspect to people of color. Some black women who were once slaves became prosperous in the new land, though Oregon was much less hospitable to blacks than other areas. Clara Brown, born in 1803 in Virginia, bought her freedom and in St. Louis, Missouri, became a cook on a party of gold prospectors. She started a laundry when she got to Colorado and eventually earned enough money to find thirty-four relatives and bring them west.

While women were in charge of the cooking in most cases, the sheer volume of the things to do meant that all hands pitched in when necessary, as there was just that much work women had to do while the men cut wood for homes and shelter and hunted game to eat. They had to be nursemaids to the sick along with their other tasks; one woman had to help her husband learn to "do something useful" when his arm was amputated by a hacksaw after a snakebite. When the husbands died, as was many times the case, the women had to lead the teams, get their families to safety and navigate the new country with what help they could find. Often that meant they remarried in haste. One gets the sense that it was not always for love as much as it was to have a companion or help-mate.

As much as the cooking part sounds like camping today, it's a far cry from modern conveniences. Byrd said of her family life:

> *'Course we us'd to make our own lights then. They wuz wick candles. The way we made 'em wuz to take wicking out the length of a candle, an' through a loop made at each end o' the wicking we'd put a stick. Then, holdin' 'em by the stick at each end—mebbe there'd be half a dozen or more wicks—we'd dip 'em in melted tallow. As soon as they'd harden we'd dip 'em again, doin' it over an' over 'til the candles wuz big enough to use. My! but didn't coal oil lamps seem wonderful when we got to usin' 'em. An' wuzn't I glad, 'cause I al'ays hed to help make the candles, soon as I wuz big enough. No, them candles wuzn't very good light, but ev'rybody went to bed early then—an' got up early too. Ev'rybody hed chores an' work to do—an' ther wuz plenty o' work I can tell you. All the cookin' o' course wuz done at the fireplace. Meat wuz roasted by putting a big piece o' tin in front o' the fire. It wuz a sort o' reflector; the meat wuz put between it an' the fire, an' you never tasted anythin' better then meat roasted that way. Bread an' pies and cake all wuz baked in the dutch oven, a big iron, round kettle that sat on short legs an' hed a long handle, an' a lid thet curved up 'round the edges. The kettle wuz set on coals, an' coals an' ashes wuz heaped on the lid.*

Amelia Stewart Knight was in the first trimester of her pregnancy when her family started their trip. Her diary is most interesting when read in that context. When she says she was bothered by the odor or the rotting cattle that had died, likely from eating poisoned wild parsnips or bad water, you can understand her reaction. When she writes about her fatigue, it is easy to imagine the bone-deep tiredness from being in a wagon day after day

and facing obstacles such as she had never seen. She took the trip with her husband and seven children. Her youngest, Chatfield, or "Chat," was small enough to carry, and she did so when the mountains made it too difficult for him to walk. Chat had scarlet fever over part of the trip and took up a lot of Amelia's thoughts and worry. Her "end of the trail" entry is dated September 1853:

Friday, Sept. 17th. In camp yet. Still raining. Noon—it has cleared off and we are all ready for a start again, for some place we don't know where.

A few days later my eighth child was born. After this we picked up and ferried across the Columbia River, utilizing skiff, canoes and flatboat to get across, taking three days to complete. Here husband traded two yoke of oxen for a half section of land with one-half acre planted in potatoes and a small log cabin and lean-to with no windows. This is the journey's end.[27]

Upon arrival, the families had to set up house with what they had left. The roads were littered midway with the things people had loved enough to take but deemed dead weight when it became impossible to pass narrow roads or traverse up cliff sides. If they were lucky, much of their household goods were intact. If not, they stumbled into town with the clothes they wore. Some arrived in Oregon City, a small town with few families, with but one stew pot to their name that served as their means to cook everything from coffee to venison.

The migrants to Oregon set up replications of the institutions they had left behind to the best of their ability. They were faced with a landscape that might have been harsh, but the beautiful landscape had potential; more importantly, it was their own to make with what they wanted. They built what they needed and prospered as best they could. Schools, churches and stores started to make life resemble what was familiar. The ideal of a better life was sought collectively. Migrants wrote home to convince their friends and family to join them. Mary Colby wrote to her brother and sister in Massachusetts in 1849, "We are in the best neighborhood I ever lived in all it wants to make it right is to have some of my friends here."

A later pioneer was the colorfully named "Klondike Kate." Kathryn Rockwell moved to the Yukon in the late 1890s to seek her fortune and became a dancer in Whitehorse and later Dawson City. In Dawson, she had a relationship with waiter turned theater owner Alexander Pantages. The pair reportedly shared an affinity for creative accounting with local miners, and the partnership ended when Pantages secretly married another woman

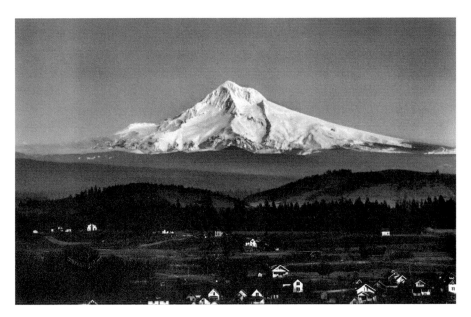

Mount Hood as seen from Mount Tabor, 1907. *Oregon Historical Society.*

and told Kate about it in a letter four days after the fact. She responded by suing him for a "breach of promise" lawsuit and eventually settled out of court for $5,000.[28]

She moved south, first to British Columbia, where she had previously been denied entrance by the Mounties. Before, she had worn boys' clothing to hop a ship to Alaska; this time, she was allowed into Canada. She made her way south and toured the country with her vaudeville act until 1912, when, after a nervous breakdown, she moved to central Oregon. First on her 320-acre spread near Brothers, Oregon, and later in Bend, Oregon, she was known as "Aunt Kate" for the way she cared for local firefighters. Rockwell "would follow fire engines with coffee and snacks," according to a newspaper article by Beau Estes in the Bend *Bulletin*.[29]

Curiously, Kate's habit of picking up rocks in the High Desert of central Oregon has gained her new fame in modern times. The more than six hundred pounds of semiprecious "agates, thunder-eggs, obsidian, and petrified wood" were built into a fireplace in her Bend home. She also donated her rocks and semiprecious stones to the construction of a grotto at the St. Charles Hospital and a fountain at the Bend Fire Department. When she died in 1957, the buildings eroded, and her house was taken

down in 1985. Perhaps not surprisingly, her collection was thought to be gone. Not so.

A rock collector from Latourell Falls, Chuck Rollins, who is also president of the Crown Point Historical Society, saw an ad on Craigslist for rocks from Klondike Kate's chimney. He bought them and is in the process of collecting more. The plan is to build a memorial to Kate with the recovered rocks.

Once they had gotten on their feet, residents found part of what they had been promised in the West. The land was rich and its rewards commensurate with how much hard work was put into it. When they arrived, they were met with the beauty that was peculiar to Oregon. Their legacy is that they persevered. These women worked incredibly hard through impossible conditions to create a new world for their families and themselves. They created the new world they desired with hard work, sacrifice, joy and faith.

Chapter 3

STRONG VOICES

ABIGAIL SCOTT DUNIWAY

O regon's Equal Suffrage Proclamation was signed on November 30, 1912. The document was signed by Abigail Scott Duniway and Governor Oswald West. The first paragraph reads:

> *Whereas: The women of Oregon, after long and patient effort, have persuaded the men of the State to place them upon a footing of political equality by granting to them the right of suffrage through an amendment to Section 2 of Article 11 of the Constitution of the State;…and vowing that the said amendment to "Section 2" of Article 11 of the Constitution of Oregon, is now, and hereafter shall be, in full force and effect as a part and portion of the Organic Law of the State of Oregon.*[30]

It was something Duniway had tried to push through for some time. She was passionate about rights for women in a way that made an incredible impact on our state. Her speeches, tireless campaigning and advocacy would last her entire life, and she was able to see her dream come to fruition before she died in 1915.

Born in 1834 near Groveland, Illinois, to a farming family, Abigail Scott lived with her mother, Anne Roleofson Scott, and father, John Tucker Scott, in the family home until she was roughly seventeen years old. The third of the couple's twelve total and nine surviving children, she did not attend much school, from all accounts, but was self-taught and loved to learn and read. Her mother, Anne, did not want to make the trip west. They left in a wagon

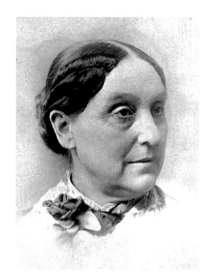

Abigail Scott Duniway. *Oregon Historical Society.*

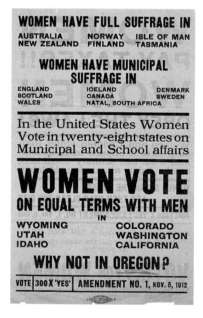

WOMEN HAVE FULL SUFFRAGE IN

AUSTRALIA NORWAY ISLE OF MAN
NEW ZEALAND FINLAND TASMANIA

WOMEN HAVE MUNICIPAL
SUFFRAGE IN

ENGLAND ICELAND DENMARK
SCOTLAND CANADA SWEDEN
WALES NATAL, SOUTH AFRICA

In the United States Women
Vote in twenty-eight states on
Municipal and School affairs

WOMEN VOTE
ON EQUAL TERMS WITH MEN
IN

WYOMING COLORADO
UTAH WASHINGTON
IDAHO CALIFORNIA

WHY NOT IN OREGON?

VOTE 300 X 'YES' AMENDMENT NO. 1, NOV. 5, 1912

A women's suffrage handbill, 1912. *Oregon Historical Society.*

bound for Oregon in 1853 with a record-keeper in Abigail, called "Jenny" by her family, who made meticulous observations during the trip. Her brother and, later, her mother would die on the road before they reached their destination. Duniway started her career as a "path-breaker," her term for one who broke boundaries, on the journey.

When they arrived, the family settled in Lafayette. Abigail Scott taught school for about a year, during which time she met and married Benjamin C. Duniway. The pair had four children. She filled her time taking care of the children and doing tasks like churning butter and milking cows on the three-hundred-acre land claim that Benjamin owned. By 1859, she was writing her first novel in the evenings, a tale of the Oregon Trail called *Captain Gray's Company*. It became the first novel to be published in Oregon.[31]

The family soon had to use her income exclusively. Disaster and injury contributed to the loss of the first farm they owned, and Abigail was powerless when the second property was lost in a poor financial transaction when Benjamin signed a note against the home as collateral for a friend's loan. She started a millinery business in Albany where they lived and contributed to local newspapers with serialized stories and articles notably concerning women's issues such as education, overwork and matrimony. The pieces jibed with her views on how women were unfairly treated. Some of her attitude may have been due to the fact that her husband's solitary decision

making contributed to the loss of their home. They moved to Portland in 1871.

The lively environment of the bigger town afforded more opportunity. After seeing Susan B. Anthony tour through, and conversing with female friends and neighbors, Duniway thought that Portland would be a good place to start a newspaper devoted to the cause of female suffrage. The newspaper, the *New Northwest*, which she founded the same year they arrived in Portland and edited for sixteen years, was an outlet for her views as well as a source for news on politics, fashion, fiction and tidbits on domestic life. Duniway lectured throughout the region and spoke passionately on subjects such as temperance, female rights and the need for "moral temperance," which she viewed as how society could advance when men and women meet as true equal partners. Her reputation grew.

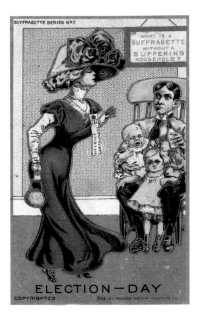

An Election Day postcard. 1909. This was typical anti-suffrage propaganda of the day. *Oregon Historical Society*.

She was asked to become the vice-president of the National Women's Suffrage Association in 1884. With hard travel over many miles and a wide lecture circuit in the Northwest, where she believed she could have the most impact, she was integral in women getting the vote in Idaho in 1896 and Washington State in 1910. Her travels and lectures were detailed in her column for the *New Northwest*, "Editorial Perspectives." An interesting fact about her stance on temperance, according to researcher Debra Schein, was that "throughout her life, she had maintained a pro-temperance, but anti-prohibition stance because, ahead of her time, she believed that alcoholism was a disease that could not be legislated out of existence." The opinion was unpopular with the all-or-nothing temperance activists.

Following is an example of her brevity and the passion with which she treated suffrage. The declaration is from the ultimately unsuccessful 1907–8 Oregon State for Equal Suffrage Campaign:

We believe in the inherent right of self-government for every law-abiding citizen and we are seeking freedom for ourselves that we may become your

legal coadjutors in the formation of a government of all the people. The mother half of all the people is rated in law with idiots, insane persons and criminals, from whose legal classification we are looking to you to release us, your wives, mothers, sisters, daughters and sweethearts, at the June election of 1908, thus leaving us free to choose for ourselves at every succeeding election as to whether or not we shall avail ourselves of the opportunities to which we know it is your duty, and ought to be your pride, to extend to us of your own volition, without waiting for the initiative to come from us. Abigail Scott Duniway, President.[32]

The vote for women in Oregon was more elusive, however. The right to vote was defeated five times by Oregonian male voters. Public sentiment was roused by not one but two Scotts; her brother Harvey was vocal in his opposition to suffrage in his place as editor of the state's largest newspaper, the *Oregonian*. She alluded to him in the first issue of the *Advocate* when she wrote, "Writing was always our forte. If we had been a man, we'd have had an editor's position and a handsome salary at the age of twenty-one."[33]

Harvey would prove to undermine Duniway's work often in his public forum. Meanwhile, Duniway continued to travel, averaging two hundred lectures a year in support of her cause. More than twenty of her novels were published serially in her newspaper, and she wrote an epic-length poem, *David and Anna Matson*, along with her autobiography, *Path Breaking*. Her children learned to set type and work in the newspaper at a young age. Her only daughter died of tuberculosis at age thirty-one. A son, David, went on to become the first state archivist of Oregon, and another son became a university president. He donated her papers to the University of Oregon, where they reside today.

On November 30, 1912, Duniway's effort with the Oregon Equal Suffrage Association came to a head when the right to vote was passed. She was asked by Governor Oswald West to write out the suffrage proclamation herself. In 1914, she became the first woman to cast a ballot and vote in Oregon. She was seventy-nine years old.

Abigail Scott Duniway. *Oregon Historical Society.*

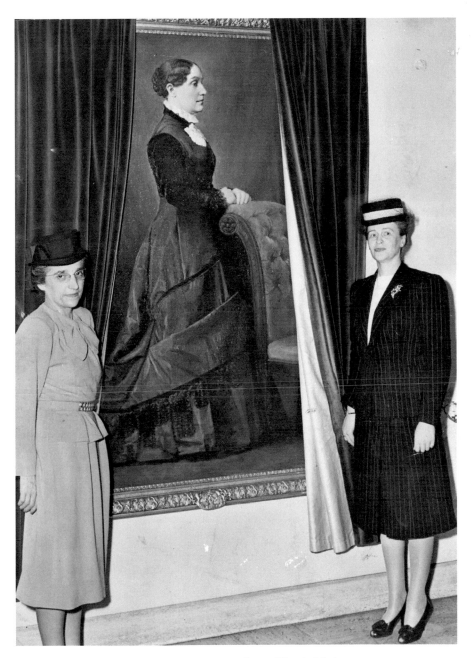

Unveiling a portrait of Abigail Scott Duniway. *Oregon Historical Society.*

Her portrait hangs in the University of Oregon's Gerlinger Hall. At one time in 1915, the plan was to place it in a building named for the visionary activist, but that changed when money became harder to raise. Schein surmises that her stance on prohibition may have swayed the university to name the building after another donor. Duniway passed away in 1915 at the age of eighty. The Sydney Bell portrait hangs at the top of the stairs leading to the Gerlinger lounge.[34]

STANDING UP FOR WHAT WE BELIEVE IN

JULIA GODMAN RUUTTILA

Julia Ruuttila came by her activism naturally. One might even call it hereditary. Her father, John Godman, was a "Wobbly," a member of the "radical labor organization" Industrial Workers of the World; her mother, Ella, was a socialist. Her path hardly veered from the argumentative or what she thought was just, and she fought for the rights of workers and citizens all over Oregon.

In a seminal photograph, she is posed with her face cocked to the side, her chin on her hand. She is wearing a dark dress with a sharply pointed white collar and cuffs and has a thin smile. Her eyes are intense under dark full eyebrows that barely arch. What is remarkable about the photo is the incongruous twine or hemp braided bracelet wrapped around her wrist three times. It contrasts with the soft, satiny nap of the dress and stands out in a way that another type of more traditional jewelry might not. The bracelet was made for her by Ray Becker, a Wobbly activist whom she supported, while he was imprisoned.

Becker was imprisoned for the role he played in the Centralia Massacre, a riot where eight members of the Industrial Workers of the World defended their hall against a mob on Armistice Day 1919. Four American legionnaires and one Wobbly were killed in a gunfight. Their attorney—a man who had advised them of their right to use weapons when defending the hall—was among the imprisoned. Witnesses said the soldiers had attacked first and the workers were acting in self-defense, but the IWW men were convicted of conspiracy to commit murder in the first degree. But second-degree murder

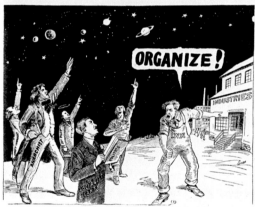

Education ★ Organization ★ Emancipation

Knowledge, like energy, is power only when it is put to work to get results.

All together, the working class knows how to make everything, how to do everything, how to create abundance and the necessary conditions for happiness for us all. But to put that knowledge to work requires organization. To get the full results that can come only from using all of it, requires organization as a class—One Big Union.

Science is knowledge organized. The I. W. W. is the working class organized—just the working class, with everybody from the coal miner to the chemist who figures out how to make a new flavoring extract out of the coal, organized to use our brains for ourselves. And it spells emancipation and a new era of abundance and security.

To start the process takes scientific industrial union education—such as you spread when you get new readers for the I. W. W. periodicals and pamphlets, pass-out I. W. W. leaflets, or put up I. W. W. stickers. Educate to organize, and organize to educate—that's the road ahead to freedom. That's where the I.W.W. is marching, and you are cordially asked to hop into the parade.

Above: Julia Ruuttila. *Oregon Historical Society.*

Left: IWW posters were used for publicity and recruitment purposes. *Oregon Historical Society.*

in the state of Washington at the time was unpremeditated murder. If they hadn't planned on murder or conspired to do so, it was hardly premeditated, according to the defense. The proceedings were bitter and plagued with anti-worker and anti–big logging interest sentiment. The trial was followed by Wobblies throughout the region and came to the attention of Ruuttila, who helped form the Free Ray Becker Committee. The others convicted of the crime were released in the mid-1930s, but Becker remained in prison until 1939, the last of the men to be paroled. Ruuttila was instrumental in keeping records related to his trial, and two document boxes, or ninety cubic feet of them, are in the Oregon Historical Society today.[35]

Ruuttila was born in 1907 to John and Ella Godman in Eugene, Oregon, and lived and was home-schooled in logging camps and on a farm. According to Sandy Polishuk, author of *Sticking to the Union: An Oral History of the Life and Times of Julia Ruuttila*, Ruuttila learned a great deal in her family home, as socialists, traveling workers and anarchists would be frequent guests. Her family would hide activists and renegade pacifists. She was influenced by her mother's radical ideas on women's rights, like the right to information on then illegal birth control, which her mother went door to door to promote. Later, she would recall her mother receiving the contraceptive information through the mail from Margaret Sanger, the woman who was the leader of the movement for birth control in America and whose organizations would evolve into the Planned Parenthood Federation of America.[36] Ella would "put the literature in a basket, covered with brown eggs, to bring it into the homes of other women, Julia hanging off her dress."[37]

Ruuttila's first marriage to William Bowen was brief. She attended the University of Oregon, where she studied during 1925 and 1926. Married for the second time to Maurice "Butch" Bertram, she had her only child, a boy, in 1928. While they were living above a sawmill, where her husband was employed, the couple organized a ladies' auxiliary and a timber workers' union.

In 1936, while involved in Ray Becker's case, she began writing for the *Timberworker*, the union newspaper, in his support. She wrote regularly for the newspaper and became its editor until 1940. Her passion in working against oppression, prejudices and racism and for peace and solidarity among workers followed her as she wrote for other union newspapers, including the Longshoremen's newspaper and the Warehousemen's Union. She wrote for the labor and farm news service Federated Press until it closed in 1956. Her pen names were Julia Godman, Julia Bertram, Julia Eaton, Kathleen Cronin and Kathleen Ruuttila, Polishuk reports, and she avoided censure by using them.

Woodworkers' union card. *Oregon Historical Society.*

In a labor strike in 1937, author Steven C. Beda writes that Ruuttila (then still named Julia Bertram) complained to the Portland City Council about the "employer goons" who had injured strikers. They threatened to picket as well and held the line with "rolling pins and baseball bats" for protection.

In 1948, while working for the State Public Welfare Commission, she reported on the victims of the Vanport flood. Vanport was "the nation's largest wartime housing development," a city outside Portland city limits founded by Henry J. Kaiser, who had contracts for warships but no place to house his workers. He bought land that was bordered on three sides by dikes and created a city with "9,942 apartment units," according to former Vanport resident Carolyn Bozanich in the book *Oregon's Main Street: U.S. Highway 99: The Folk History.*[38] She said of the town:

> *Vanport was a melting pot, inhabited by lonely, overworked souls. It sprang from swamp land and as each unit was finished, people from different states and different cultures were jumbled together. I played with a Jewish girl from New York who lived in our building and my best friends were Catholic girls from Minnesota. We moved here from Yoncalla, a small town in the central part of Oregon, and I had never known any people who weren't white and Christian.*

The city, named "Van" for Vancouver and "port" for Portland, between which it resided, was populated by people from all over the country to work on the warships. About 40 percent of the population was African American. It was heavily segregated as far as residence but not in schools, and the area had an unprecedented level of racial progression, due to the policies of the Housing Authority of Portland (HAP), which administrated Vanport. Bozanich recalls:

Many black people came to Vanport. They were kept to themselves in an area on Cottonwood Street, separated from the rest of the population by the slough. That was the only segregation. I had never known a black person, or even seen one up close, until Vanport. The school was not segregated. There were two black boys in my eighth grade class. We elected Burton, a soft-spoken, polite boy as our class president, but he declined. He was sixteen years old and working full time in the shipyards.

The spot was near the amusement park Jantzen Beach. The park hosted popular big-band music, including greats like Tommy Dorsey, in its Golden Ballroom. Vanport became the first place where black policemen and teachers were hired in Oregon. Black teacher Martha Jordan would go on to be the first black teacher hired by the Portland Public School System. Its population decreased significantly after the war when many people drifted back to where they had come from, despite the presence of a college that had opened in town and the efforts of the government toward attracting veterans to its housing.

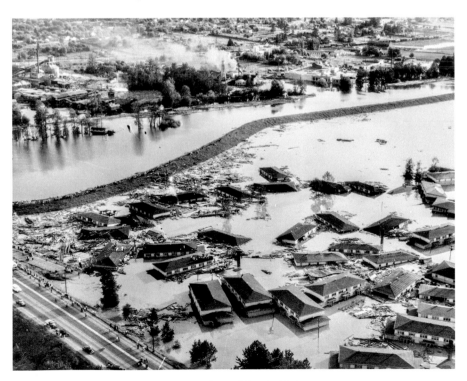

The Vanport floodwaters in June 1948. *Oregon Historical Society.*

The city was decimated when a flood pushed over the dikes and gave the estimated 18,500 people only thirty-five minutes to escape. The destruction was particularly brutal among the percentage of the population that used the crowded public transportation system, which, according to some residents, was always packed virtually shoulder to shoulder. Fifteen people died. Ruuttila's newspaper article, which advocated for the African Americans who were left homeless and decried the efforts the city made to help the impoverished community, helped the event become a lightning rod for racial debate in the state. It also lost Ruuttila her job at the state and outed her as the author of politically charged writing.

After her marriage to Oscar Ruuttila in 1951, she moved to Astoria, Oregon, and worked with the Columbia River Fisherman's Protective Union. She was subpoenaed to testify in front of the House Un-American Activities Committee in 1956 due to her interest in the Oregon Committee for Protection of the Foreign Born. It turned out that the Federal Bureau of Investigation had been interested in and had Ruuttila under surveillance since the 1940s. She denied membership in the Communist Party.

Outing on the Columbia. What the Columbia River, the largest river by volume flowing into the Pacific Ocean, looked like before dams were erected. *Oregon Historical Society*.

When Oscar died in 1962, Ruuttila moved back to Portland and continued her activism. She had trouble paying bills and reportedly attempted suicide over an unpaid phone bill that was too much for her to deal with. Her struggles continued with domestic violence, multiple abortions and single motherhood. She joined antiwar protests and anti–nerve gas protests and continued her investigative reporting. She worked up until her last years and died living near her grandson in Anchorage, Alaska, in 1991.[39]

When she was in her eighties, she self-published a book of her poetry. Stephanie Taylor, who found one of the spiral-bound and mimeographed books, writes that the two hundred poems are meaningful and poignant and that they create a through-line that connects her activism and feminism. The first stanza of "Long Log Country" goes:

> *This is Long Log Country—I was born*
> *With sawdust in my veins, the silver sound*
> *Of crosscuts in the stillness like a wound*
> *Troubled echo of the hunting horn.*

While the last stanza brings in her experience:

> *I can remember, too, where bullets sped*
> *Soft-nosed and deadly in the summer dawn*
> *And strikers in the clearing doomed and dead.*

It can be read as a eulogy for the union struggle or an analogy for war. The two stanzas, taken alone, could also read as grief for a way of life gone by.[40]

THE MARGINALIZED

BEATRICE MORROW CANNADY AND HAZEL YING LEE

In 1889, she was born in Littig, Texas, and later she was a teacher in Oklahoma. She attended the University of Chicago, was technically the first black female lawyer in Oregon and, in 1974, at the end of her life, died almost unrecognized in Los Angeles. But her pioneering work as a civil rights activist is what Beatrice Morrow Cannady is remembered for in Oregon.

One of twelve surviving of the fourteen Morrow children, Beatrice was born to an educated household where her early love for music was nurtured. Little is known of her life in Texas; as a teacher at Logan County High School in Guthrie, Oklahoma; or her time as a student of voice training and at the University of Chicago before her move. In her seminal work about the activist, Kimberly Mangun, working from material from the Morrow and Cannady families, reports that the Morrow family was active in church and civic events and that many of her siblings acquired success and degrees in higher education. Reportedly, she also left little in the way of personal journals and other ephemera from that time. What Beatrice Morrow Cannady has left us is a heritage of advocacy that is still instructive today.

Her arrival in Oregon came in 1912, when she married Edward Cannady after a long platonic correspondence by mail. Edward was a former hat-check in the Portland Hotel and editor and co-founder of the *Advocate*, Portland's largest and occasionally its only black newspaper. Edward, a civil rights activist himself who had started the *Advocate* in 1903 with nine partners, must have been a draw for Beatrice. An editorial in the

The E.D. Cannady home at Twenty-sixth and Brazee in Portland, about 1911. *Oregon Historical Society.*

newspaper's first issue of September 5, 1903, states, "With this issue *The Advocate* makes its initial bow to the Portland public as an independent, non-partisan, non-sectarian weekly newspaper for the intelligent discussion and authentic diffusion of matter appertaining to the colored people, especially of Portland and the State of Oregon."[41]

The appeal of the newspaper was quite a draw to the approximately one thousand African Americans living in Portland at the time. Its three

thousand subscribers counted influential people and political figures like the Oregon governor among them. The paper reported on important issues like lynching and segregation to help ensure they were kept in the public's awareness, and it was a source of employment opportunity as well. Oregon was founded on racist principles and was known as a "sundown state," where people of races other than white were strongly encouraged to leave town before the sun set, on threat of violence. Oregon's constitution is not uncommon, as a state in the Union still struggling with the post–Civil War racial divide, in having exclusionary articles written into it:

> *Article I Section 35.——No free negro, or mulatto, not residing in this State at the time of the adoption of this Constitution, shall come, reside, or be within this State, or hold any real estate, or make any contracts, or maintain any suit therein; and the Legislative Assembly shall provide by penal laws, for the removal, by public officers, of all such negroes, and mulattoes, and for their effectual exclusion from the State, and for the punishment of persons who shall bring them into the state, or employ, or harbor them. (Repealed November 3, 1926).*

Beatrice went on to become editor and co-publisher of the newspaper from 1919 to 1930. She and Edward had two children together, Ivan and George.

The team of Edward and Beatrice was a potent one. United in promoting civil rights, they campaigned against the unfair laws then in practice and worked actively to protest them. Beatrice wrote editorials in the *Advocate* about the effects of pervasive racism on the African American population, writing letters to Oregon senators and cannily sending copies to the local newspapers. An example of this is their letter in the January 14, 1915 *Morning Oregonian*:

> *Dear Sir:*
> *As the anti-intermarriage bill puts a premium on prostitution and takes all protection away from the colored man's family, the Portland branch of the National Association for the Advancement of Colored People requests that you use your influence as an intelligent, civilized Christian gentleman and vote against the same.*
> *J.A. Merriman, president; E.D. Cannady, chairman of executive committee; Beatrice Morrow Cannady, secretary.*

Beatrice Morrow Cannady in 1926. She made the shawl she is wearing in this photo. *Oregon Historical Society*.

She spoke at hundreds of events—schools, institutions and meetings—to further her cause. In 1914, she was one of the founders of the Portland chapter of the NAACP and spoke in front of the group's nineteenth national meeting. At the meeting in Los Angeles in June 1928, the first held by the NAACP on the West Coast, she gave a speech that highlighted her practical advocacy and touched on one of her common themes: education. It is no surprise, as a former teacher, that she emphasized the home as a center of knowledge:

> *As the Greek and Roman mother sang lullabies over the cradles of their babes descriptive of heroic deeds such as fired their infants' hearts with an ambition and a determination to excel—so the Negro mother of today must do likewise. The ignorance of the Negro race's history both ancient and modern among Negroes themselves is colossal. It seems that there are those who really pride themselves upon knowing as little as possible of the race.*

Her talk provided a call to African American women to be "spiritual conservators" and leaders of their communities as well as their families. She advocated teaching children their human and civil rights from an early age and making the cultural experience be a conversation had in the home:

> *It is the duty of the Negro woman to see that in the home there are histories of her race written by Negro historians. She should see to it that there are books of fiction, poetry and serious works. That pictures, paintings, etc., are in the home. The Negro mother has it within her power to invest less in overstuffed furniture for instance, and more in books and music by and about the Negro race so that our youth may grow up with a pride of race which can never be had any other way.*

The branch of the NAACP in Portland, founded in 1909 with Cannady as its secretary, is the oldest continuously chartered branch of the organization west of the Mississippi. Work by the organization helped repeal exclusionary voting laws in the state and give African Americans the right to fair housing with "equitable treatment in many service and labor jobs."[42] The NAACP would later support civil rights in a June 1963 protest when Medgar Evers was killed in Mississippi.

In her hundreds of articles for the *Advocate* she fought for the rights of women, African Americans and Chinese. When her sons, Ivan and George, were thirteen and fifteen, respectively, an incident occurred that would

precede Rosa Parks's historic bus sit-in but would echo similar sentiments. When her family arrived at the Oriental Theater one night in 1928, they were refused entry to the main floor on the grounds that only whites were allowed there. Beatrice maintained that she had purchased a ticket and recalled in the *Advocate* on December 8, 1928: "Plenty of seats [are available] downstairs, and…as I am a law-abiding citizen, presentable and have paid admission…I prefer to sit downstairs and shall do so."

She continued to push the margins by hosting teas for influential people of both races and discussed civil issues as well as books and music. In 1919, she invited the talented singer Roland Hayes to one such tea. She promoted Hayes in the *Advocate*; went on to feature other performers, like vaudeville stars the Johnson Brothers; and succeeded in making black musicians, music and literature much more popular in the state. Her interracial teas were a place to display her library and allow others to borrow from her wide collection of books written by and about African Americans, but they were also a chance at unity between people of all stripes. An *Advocate* article about her teas describes them: "It is a picture never to be forgotten, for its great beauty and the joy it affords to witness one of these gatherings where white and black, rich and poor, Christian and Jew mingle freely and discuss their common interests while sipping together a cup of tea!"

The lectures, poetry readings and cultural events she hosted or promoted added to the awareness of discrimination in the state and the country. As many as two hundred people attended her Sunday teas. Her work, along with her work in the newspaper, served to strengthen the black community in Portland and in the nation in the time between 1912 and 1936. In addition, she spoke about black literature and her civil rights work on the radio.

The film *Birth of a Nation* was released in 1915. Cannady fought against the film's national release and asked city officials to keep it from releasing in Portland in a petition to the city's governor. She also petitioned to keep the Ku Klux Klan from forming in Portland. In the state already inclined to a whites-only agenda, her heroic work went a long way toward improving race relations, but the Klan found fertile ground in post–World War II Oregon. Members of the group migrated to southern Oregon in the early 1920s, and by the end of the decade, they had affected the politics of the state. Even politicians such as Mayor George Luis Baker, while not an active Klansman, were connected to the group and influenced by it through membership in other fraternal organizations. Internal friction limited Klan power after the mid-1920s. Oregon had a brief stint of infamy after a Klan-backed bill targeted at Roman Catholics was passed that required children ages eight to

sixteen to attend school. Oregon was the only state that had such a law, and it was pronounced unconstitutional in 1925. By then, the political arm of the Klan was starting to wane, but its social effects lingered.

In 1922, Beatrice graduated with her degree from Northwestern College of Law. She attempted to pass the bar exam five times but ultimately failed to do so. She did practice and carries the label of the first black woman to practice as a lawyer despite not having passed the bar. In 1935, she was asked to cease practicing after having helped countless people with their legal battles.

Prominent ministers, professors and even the president of Pacific College lent their support when Cannady was nominated for the 1929 William E. Harmon Award for Distinguished Achievement Among Negroes in the Race Relations field. The Harmon Foundation was started in 1922 to give monetary awards to outstanding black authors and artists of the Harlem Renaissance in eight different fields. She lost the award to Robert Russa Morton, president of the Tuskegee Institute, but her nomination was an immense honor.

Beatrice divorced Edward amid some scandal in 1930. It was again a bold move for the time. She and Edward split their property far more evenly than might be expected, including child support, property, cars and ownership of the *Advocate* and its offices for as long as she continued to publish it. Her pro–civil rights agenda was promoted in the newspaper to affect not only its readers but also a state that so clearly needed to hear the voices of the people it had marginalized. Cannady's modernity affected not only by word but by deed as well.

She attempted to gain election as a state representative from the Fifth District of Multnomah County in 1932. Although she lost, the receipt of almost eight thousand votes from a primarily white constituency was an impressive showing.

Cannady was the first African American woman to run for office in Oregon, and she was also instrumental in creating the state's first civil rights legislation. If the legislation had passed, it would have required "full access to public accommodations without regard to race," according to the Oregon Historical Society. Though it failed, momentum gained by the legislation came to fruition in 1927 when the law prohibiting those who were black, mulatto or Chinese from voting was repealed.

Cannady left the state in the late 1930s. She was married to her third husband, Reuben Taylor, whom she called the love of her life. She converted to Bahai'ism in her home of Los Angeles. Her life was lived away from the

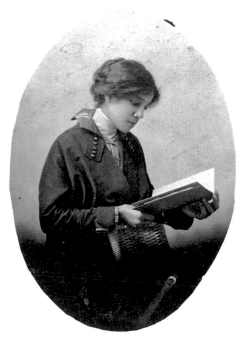

Left: A portrait of Beatrice Morrow Cannady. *Oregon Historical Society*.

Below: Beatrice Morrow Cannady surrounded by children in 1973 after a presentation at a school. *Oregon Historical Society*.

spotlight until her death on August 17, 1974, and she was buried with a Bahai ceremony.[43]

It seems incredible that there aren't more monuments or publicly lauded events centered on Cannady, given her story as a prolific and popular activist. A move was made in 2013 to name a light rail bridge after her, but it failed. Later in 2013, a group of students at Portland State University started a walking tour to remember Cannady and her fellow inspirational women.

The Walk of the Heroines is a public walk and park to honor women of varied backgrounds who have contributed to Oregon culture and society. It takes a broad view and provides space to female artists, civil rights pioneers, organizations, teams, foundations and individuals. Cannady was honored with a spot on the Naming Wall on the Walk of the Heroines on the campus of Portland State University, off the South Park Blocks and in front of Hoffman Hall. The walk is beautiful, quiet and peaceful, a place to learn about powerful women from Oregon and beyond. Best of all, it brings awareness to what these women have done so that future generations can see and understand their impact. As reporter Anna Griffin said when she reviewed the Walk in the *Oregonian*, the largest newspaper in Oregon, "But the trees and plants just need time to grow, and there's plenty of room for more names. Now all Portland's newest public space needs is discovery. Take your lunch. Better yet, take your daughter."[44]

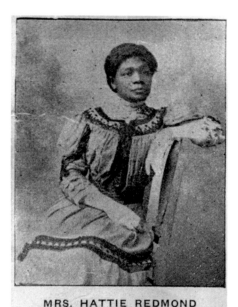

MRS. HATTIE REDMOND

One of Portland's progressive women who did much toward winning the ballot for women in Oregon.

Hattie Redmond. *Oregon Historical Society*.

Other notable African American women were instrumental in the struggle for voting and civil rights in Oregon, echoing the advances made by Mary Beatty, a woman whom newspapers called "colored" and who voted with Abigail Scott Duniway in the 1872 presidential election. Activist Lizzie Coontz Weeks helped mobilize African American women's voting rights by focusing on voter registration. Another activist, Harriet "Hattie"

Redmond, president of the Colored Women's Equal Suffrage Association in 1912, helped facilitate voting and civil rights through her work.

The State Equal Suffrage Association made Mrs. Henry Coe its head after Abigail Scott Duniway (profiled in chapter 3) stepped down due to health concerns. Shortly afterward, the association of African American women met in Portland's African Methodist Church to discuss the suffrage association. The *Oregonian* reported on May 15, 1912, that the groups decided to join "to form an allied association for negro women who are members of any of the five churches, with the object of spreading equal suffrage ideas among those of the race."[45]

Their efforts, and those of many others, were rewarded when Oregon gave the right for women to vote in 1912. This basic civil right, of contribution to one's future through stating one's opinion without fear of malice, would not be possible without the work of Beatrice Morrow Cannady. That being said, the traces of racism evident in our whole country are still seen in Oregon today. But by learning about women like Cannady, we can inform and build on the work of our forebears.

The constitution of Oregon was inhospitable to people of other races as well. One could argue that Oregon was fairly blatant about its racism, even given the common social mores of the day. The Oregon Land Donation Act granted 320 acres of land to each white male over age twenty-one, regardless of the native or tribal members who might be living there. Thus, any Native Americans already in residence on the land were just not a concern for the white people settling the area. The exclusionary tactic was written as part of the Oregon Constitution, forbidding the right to representation by voting: "Article 11 Section 6.—No Negro, Chinaman, or Mulatto shall have the right of suffrage. (Repealed June 28, 1927)."[46]

Given that the "free land" of Oregon was in actuality a free land primarily for white families, it is no surprise that Chinese and Japanese were also written out of the original state constitution in 1857. But Oregon was a state that, as part of America, offered a chance to learn a new culture but more so a place to earn money to send home to families still in the East. Chinese immigrants started coming to Oregon as early as the 1850s after large contractors arranged for laborers for the new railroads, and they were mainly from the Cantonese-Chinese Pearl River Delta region. The workers were largely young men. These Cantonese-Chinese were mostly miners, especially in Josephine and Jackson Counties in southwest Oregon. The number of women, then, was minimal. Author Douglas Lee states,

"Continuous migrations of single young men, however, did not require permanently structured communities. There were no Chinese women as wives and mothers—just a few prostitutes and slave girls—and certainly no Chinese families."[47]

The numbers of immigrants changed after the 1860s. The Chinese population attracted a bigger demographic to a more widespread part of Oregon after technological advances allowed for more industry in mining, shipping and travel. Especially after 1865, railroads increasing and multiplying became a source of income and employment for many Cantonese-Chinese. In this way, the population of Chinese was able to spread through southwest Oregon. Families, who were steadily increasing, were curtailed some in 1866, when the state made it illegal for whites to marry anyone one-quarter or more Chinese or Hawaiian and also illegal for whites to marry anyone who was one-half Native American. The law was nullified when Oregon adopted the Fourteenth Amendment to the United States Constitution:

> *All persons born or naturalized in the United States, and subject to the jurisdiction thereof, are citizens of the United States and of the State wherein they reside. No State shall make or enforce any law which shall abridge the privileges or immunities of citizens of the United States; nor shall any State deprive any person of life, liberty, or property, without due process of law; nor deny to any person within its jurisdiction the equal protection of the laws. (Amendment 14, Section 1)*[48]

Curiously, Oregon did not wipe the law from the books until 1951. The growth of Portland and its location as a shipping hub contributed to expansion by Chinese from various regions to Oregon in the 1880s. Large groups contributed to agriculture in the Hood River and Willamette Valley areas. Many Chinese took jobs in canneries, as domestic workers and as service workers. In short, Chinese were assimilated into the job market in most areas of Oregon's workforce just as the white workers were.

However, the rise of the Ku Klux Klan in the late 1800s and early 1900s set the stage for racism in areas all the way up to the governor's office. On May 6, 1882, the Chinese Exclusion Act gave the nation the right to stop the import of cheap labor and racial mixing, led by the backlash and fear of the influx of Chinese labor. That act led to an increase in Japanese immigration for a time. The Geary Act in 1892 curtailed travel by those of Chinese descent, allowing laborers to travel to China and reenter the United States

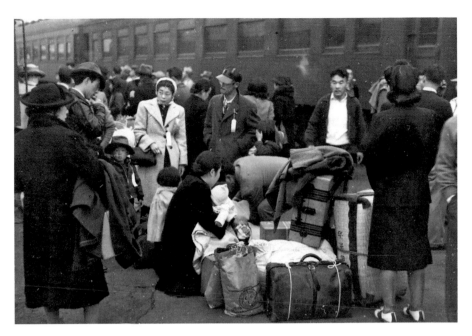

Japanese people during relocation. *Franklin D. Roosevelt Library, National Archives and Records Administration.*

but only when registered. Those without paperwork faced deportation or even imprisonment.

Walter Pierce, who could be said to have been influenced by Klan politics and, indeed, was photographed with Klan higher-ups, supported legislature to pass the Oregon Alien Land Act in 1923. The act made buying or leasing land illegal for people of Chinese or Japanese descent.

It was into this political climate that Hazel Ying Lee was born.

As has been shown, Portland in 1912 was not a hospitable place for a Chinese American. Things were looking hopeful for Chinese women when Oregon gave women the right to vote that year, but it did not extend to those of Chinese descent. The dissolution of the Quing monarchy in 1911 in China was thought to give women the vote in China itself, but this proved to be false hope when they were excluded from participating in the new democracy. They would finally be granted the right to vote in China in 1947.[49]

Hazel Ying Lee's parents, Yuet Lee and Ssiu Lan Lee, had met as immigrants to the United States while in Portland. She was one of eight children born to the hardworking merchant couple. Her brother Victor

Lee would become a serviceman with the U.S. Tank Corps. As a student, Hazel likely attended the Chinese language and culture classes after school each day that most Chinese children in Portland did at the time. She learned a few things that women did not do in that era as she was growing up, like how to play cards, drive a car and swim. After her graduation from Commerce High School, she was employed as an elevator operator, one of the jobs open to Chinese American women, at Liebes Department Store in Portland. Elsie Chang, Hazel's friend, said, "In those days jobs available to Chinese girls were only elevator operator or stockroom girl. Doing office work was just a daydream."

Hazel became fascinated with flying after her first flight and joined a class in 1932, courtesy of the Chinese Benevolent Society, to learn to fly with the Chinese Flying Club. Her instructor was noted aviator Al Greenwood. In October of that year, she became the first Chinese American woman to get her flying license. Frances Lee Tong, Hazel's sister, said, "Hazel just told my mother that she was going to learn how to fly. My mother said she was so ahead of her time."

Hazel traveled to China to live with relatives in 1932 with two siblings when times were hard for the family during the Great Depression. Upon the Japanese invasion of China, she attempted to become part of the Chinese Air Force, along with fourteen other Chinese Americans living in Canton. The Chinese Air Force would not accept a female fighter pilot, despite her experience. One of the others in the group, a man called Clifford Louie Yim-Quin, was accepted. He would go on to become Hazel's husband. He had an illustrious career and eventually became a general in the Chinese Air Force. He would go on to be chief executive officer of China Airlines. Undeterred by her refusal by the Chinese Air Force, Hazel worked with a group for the purpose of pro-Chinese propaganda. She also flew for a private airline in Guangzhou (southern China) to increase her flying expertise and helped found a school.[50]

When the Japanese invaded China in 1937, Hazel stayed where she was. According to others in the area, her calm demeanor was a help to other Americans in the region throughout the bombing and warfare. She tried to join the Chinese Air Force again and was again rejected. After her escape to Hong Kong, she returned to the United States.[51]

As events progressed toward World War II, the environment for Japanese Americans deteriorated. President Franklin Roosevelt signed Executive Order 9066, which "authorized the evacuation of all persons deemed a threat to national security from the West Coast to relocation centers further

The front page of Executive Order 9066.
National Archives and Records Administration.

inland." Thousands of people were relocated to internment camps in the Northwest and elsewhere.

Now thirty, Hazel applied for service in the Women Airforce Service Pilots (WASPs) in the United States. Entering flight school at Avenger Field in Sweetwater, Texas, on February 21, 1943, she did well according to reports, loved to fly and graduated on August 7, 1943. The yearbook photo of Lee shows a confident woman with neat appearance, much like the other WASPs. The yearbook itself from Sweetwater has a logo designed by Walt Disney, of all people. It shows a female named Fifinella with wings and a flight helmet posed as if jumping through the sky. If you look closely, the figure is not dissimilar to later female cartoon characters by the artist. It was originally created for a film and later children's book by Roald Dahl, *The Gremlins*, and Disney allowed the service to use it in World War II.

Eleanor Roosevelt commented in 1942: "This is not a time when women should be patient. We are in a war and we need to fight it with all our ability and every weapon possible. Women pilots, in this particular case, are a weapon waiting to be used."

Based at Romulus Air Base in Michigan, Hazel was soon ferrying fighter airplanes from airports to shipping locations all over the country. She was an excellent cook and was sought after as a fellow on overnight stays because if she didn't know the best places to eat in the area—and she often did—she would cook. She and other WASPs were responsible for ferrying more than five thousand aircraft to be transported to Alaska and the Soviet Union or other points for combat.

Once, she was towing an aircraft across the United States when she had to make an emergency landing in the middle of a field in Kansas. The farmer mistook her for a Japanese pilot, not being aware of the

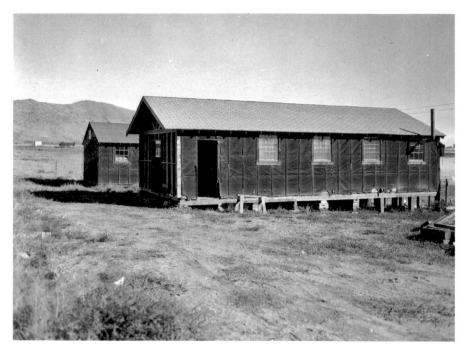

Barracks from a Japanese American internment camp. *OSU Special Collections & Archives, via Wikimedia Commons.*

females in service at the time. He chased her around the airplane with a pitchfork until she was able to identify herself and calm them both down.

Hazel was ferrying a P-63 Supercobra from the Bell manufacturer in Niagara Falls, New York, to Great Falls, Montana, on November 10, 1944. In the midst of a crowded airport only just cleared of an incredible snowstorm, there was much confusion among the aircraft attempting to land. Hazel and another aircraft crashed into each other, and the planes went down. Hazel was pulled from the flaming wreckage by her jacket, which was on fire. She would not recover from the burns and injuries caused by the collision and died two days later, on November 12, 1944. Her death would be the thirty-eighth and last of the WASPs to be killed while on active duty. WASPs were considered civilians, not soldiers, and thus were not entitled to military benefits or burial.

A WASP veteran commented, "We were raw civilians though. We didn't get the pay, we didn't get life insurance, we didn't get anything. We worked for a lesser salary than the second lieutenants, which was the lowest grade of the pilots."

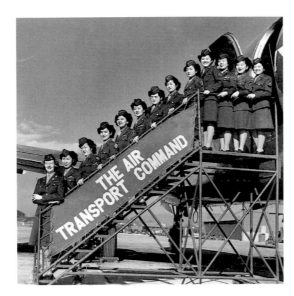

Left: WASP Transport command. *Courtesy of the Department of Defense. (The appearance of U.S. Department of Defense (DoD) visual information does not imply or constitute DoD endorsement.)*

Below: Four members of the United States Women Airforce Service Pilots (WASPs) receive final instructions as they chart a cross-country course on the flight line of a U.S. airport, 1942–45. *Office for Emergency Management, Office of War Information.*

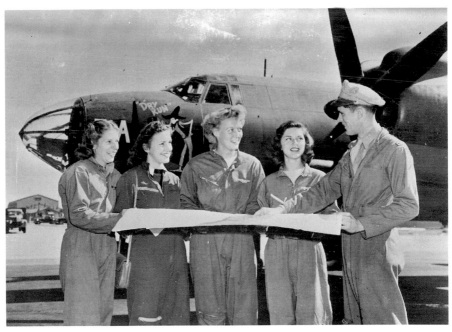

To add to her parents' loss, Hazel's brother Victor was killed in action three days after her death. When her family requested that their children be buried together in a plot in the Riverside Cemetery in Portland, they were denied on the basis of race. Their sister Florence wrote to President

All Hands, April 1949. This was a widely distributed service magazine. *Bureau of Naval Personnel, via Wikimedia Commons.*

Roosevelt in indignation. The cemetery reversed its policy, upset about the potential for bad publicity, and the pair is buried side by side in Riverview.[52]

As the two countries were allies, the anti-Chinese exclusion acts were starting to be repealed as of 1943, when the first Chinese American man was naturalized in California. The laws got better, but the WASPs were not publicly recognized when they were disbanded in 1944 or thereafter for some time. The remaining WASPs and their families tried to fight for military status, and eventually President Carter signed a bill in 1977 to give them military benefits, with honorary discharges awarded the following year.[53]

Hazel was inducted into the Oregon Aviation Hall of Honor at the Evergreen Air Museum in Oregon on October 24, 2004. On March 10, 2010, she and the other WASPs received the Congressional Medal of Honor at the Gold Medal Ceremony on Capitol Hill.[54] Her name is a star on the Walk of the Heroines on the Portland State University campus.

Chapter 6

PETTICOAT GOVERNMENT

LAURA STOCKTON STARCHER AND BARBARA ROBERTS

The term "petticoat government" was made, really, for reluctant politician and mayor Laura Stockton Starcher and her band of friends in Oregon government. Her husband, E.E. Starcher, was the incumbent mayor of miniscule Umatilla, Oregon, where they lived. It was a sparsely populated county with a lot of space to farm, and wheat production was very popular after the railroad came to the area in the 1880s. The Umatilla Indian Reservation was composed of the Umatilla Confederate Tribe (Cayuse, Umatilla and Walla Walla) and was made in the area with the Treaty of Walla Walla in 1855.[55] Most people in the roughly 3,200-mile region didn't even bother to vote anymore in the town that was run by the "good old boys," so E.E. didn't put on a campaign. There were only 198 souls there anyway. Nobody had ordered ballots.

Women in town had a different plan. Umatilla was run-down, and they weren't happy about it. Laws weren't being enforced; the sewage was rank. Since the vote for women became legal in Oregon in 1912, women of the area had wanted more of a say in how things were run. So one day, at a card party held at the home of the wife of a city council member, a coup was organized. It was executed with subtle tactics and took the men then in power by complete surprise. When the dust cleared, Laura Stockton Starcher was mayor, Bertha Cherry was city auditor, Lola Merrick was town treasurer and "Gladys Spinning, Florence Brownell, H.C. Means, C.G. Bromwell, and Stella Paulu took all but two of the city councilmen seats," according to author Hannah Keyser. Laura had won the mayoral vote twenty-six to

An Umatilla, Oregon wheat field. Photo by Dorothea Lange, 1939. *Library of Congress Prints and Photographs Division, Washington, D.C.*

eight. E.E. Starcher demanded a recount in the days after the election, but she had indeed won.

This all happened without the knowledge of the previous mayor. The headline of the *East Oregonian*'s daily evening edition on the day subsequent to the election shouts, "Women Tell How They Best Men" and goes on to say, "Didn't Even Know a Female Ticket Was in the Election Field Until Late Afternoon of Election Day—Awakening Then Was Too Late."

Mayor Starcher seemed quite put out about it. He is quoted in the article as saying, "I didn't know a thing about it until election day. I felt secure about it but I got busy at once. Everywhere I went among old adherents I found they had voted for my wife and I thought all the time they had voted for me."

The upheaval was due to the laissez-faire mentality that had pervaded the Umatilla society for some time. The present administration had been letting city affairs run along the lines of least resistance. Laws were slackly enforced, city improvement was at a standstill and Umatilla was rapidly retrograding back into the sagebush stage of years ago.[56]

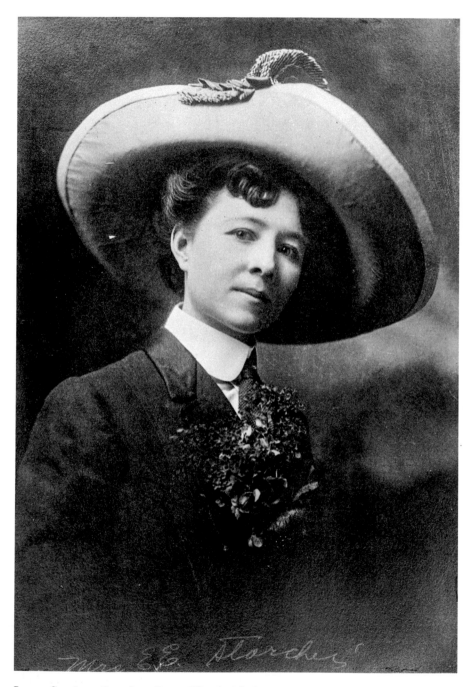

Laura Stockton Starcher. *Oregon Historical Society.*

New mayor Laura Starcher promised a business-like, progressive administration. She had a long list of improvements that she wished to undertake for the city. She wanted to replace the streetlights, "which the present administration removed"; repair sewers; and clean up the roads and streets. She also promised a female police chief, seeing as the male one they had didn't perform his duty.

The women's government was not long-lived. Mayor Laura Stockton and her female cohort were in office just four years, and the "mayoress" herself left office after several nervous breakdowns eight months into her term. Her position was taken by Councilwoman Stella Paulu. When they moved on in 1920, there was no new female government to take over from them. Evidence has yet to be provided as to the reason, but an article in the *Oregonian* claimed that the Stocktons divorced shortly after the 1916 election.

The aim of the petticoat government, as stated by Laura Stockton Starcher, was to provide real civic change. Despite her short term, it was a success; the group managed to fulfill its goals of improvement within the town.

One of the most influential females in our governmental history is Barbara Roberts. She came to politics for intensely personal reasons. Her son, who is autistic, was "denied the right to a public education." She helped to change that and, in the process, changed how disabled people could receive education in the United States.

She was an Oregon native, born in Sheridan, a farm and logging town in Yamhill County, and descended from pioneers who came west on the Oregon Trail. Attending school, she was a goal-oriented person who achieved what she set out to do, according to a review of her autobiography, *Up the Capitol Steps*, in the *Willamette Week* newspaper.[57]

Marrying while still in high school was not unusual in Sheridan in 1954. She married Neal Sanders a year before graduation and moved with him the next year to Texas, where they had two boys before they moved back to Portland, Oregon. It was in 1962, while she was studying at Portland State University, that the couple became worried about their first son, Mike. He had not learned to be toilet-trained by age six and had inappropriate emotional outbursts.

"[T]he diagnosis was a devastating one," her autobiography states. "The doctor's label: 'extremely emotionally disturbed.' They recommended Mike be permanently institutionalized! These 'experts' predicted Mike would

never be able to go to school, never work, never be able to live independently. I was stunned." He would later be identified as having autism.

Roberts would graduate from Portland State in 1964 and continue her education later at the John F. Kennedy School of Government at Harvard and Marylhurst University. She and Neal divorced in 1974. But her advocacy for disabled children began shortly after Mike's diagnosis. In 1969, she lobbied for disabled children and was successful in lobbying the Oregon legislature to guarantee educational rights for children with disabilities. Serving on the Parkrose School Board led to a position serving on the Mount Hood Community College Board. Her marriage in 1974 to Frank Roberts would last until his death.

She then worked at the Multnomah County Commission and was elected to the Oregon House of Representatives in 1981. Her second term would see her elected as the first female Majority House leader. In 1984, she became the first Democrat elected secretary of state in 114 years. Her autobiography notes that the Portland Gay Men's Choir, which sang at her inauguration, is thought to be the first homosexual choir to perform at the inauguration for a statewide elected official in the United States. She enacted election reforms and oversaw a new state archive built, and she helped give broader audit powers to the office of the secretary of state.[58]

In 1990, she decided to run for governor after Governor Neal Goldschmidt decided not to run again. Roberts was elected in November of that year, the first female governor of Oregon. Her administration worked to fund the Oregon Health Plan, which offers affordable healthcare to all Oregonians. She worked to increase the number of children in Head Start, a program to help youth succeed. Her office worked to appoint "women and minorities to

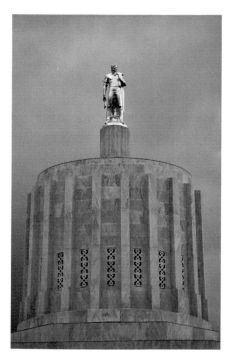

Oregon Capitol, *The Golden Pioneer*. He was gilded originally by proceeds from a penny drive among children in the entire state of Oregon. *Photo by the author.*

Governor Barbara Roberts. *Oregon Historical Society.*

positions in state government," as the *Focus on Oregon History* entry on Roberts attests.[59] She helped the environment through things like mining legislation and the protection of fish and wildlife. The thirty-fifth governor of Oregon's term was completed in 1995.

Her husband, Frank, passed away while she was still in office. She is the author of a book, *Death Without Denial, Grief Without Apology*, and is on the board of several nonprofits. For a brief time, Roberts filled a vacated spot on the Portland Metro council, and she is now a sought-after public speaker. A public school was named after her in Salem, Oregon, in 1996. She lives in the Portland Metro area and continues public service through volunteering.

Chapter 7

WORKING WOMEN

LOLA BALDWIN AND IONA MURPHY

Lola Baldwin started out as Aurora "Lola" Greene in Elmira and then Rochester, New York. She became a teacher in the public school system after her father died and then moved to Nebraska, where she taught and met and married LeGrand Baldwin in 1884. Her husband and their two boys moved several times. Baldwin continued to serve young women, not as a formalized teacher, but through volunteer social work for unwed mothers and children. As a board member at two different Florence Crittenton homes, she helped prostitutes and single pregnant women learn marketable skills.

LeGrand Baldwin, previously the owner of a dry goods store, eventually worked for the E.P. Charlton Company, which had a chain of stores across the county. He was asked to run the company's first Portland store in 1904. The family moved there, and both Lola and LeGrand worked on the board of the Florence Crittenton home there.

Later in 1904, the city prepared for an influx of people for the 1905 Portland Exposition. It anticipated "non-resident criminals," as well as young people, specifically women and girls who might be coerced into sexual activity by unsavory characters. To combat this, different women's aid groups formed ways to help the incoming women by meeting them at railway stations. They provided resources to help the women find employment and housing rather than be lured away into prostitution or crime. The Traveler's Aid Society and the Portland YWCA were two of these aid groups.[60]

Baldwin was considered very skilled at helping these "wayward girls," as they were called, and often spent time doing detailed investigations and interviews of and about the girls in order to better help and place them. Because of her experience helping organize what had become Portland's juvenile court, the YWCA hired her as supervisor of the Traveler's Aid program. Her goal was helping the girls get education, employment or housing rather than a police record, and she visited the women in homes and workplaces to do so.

When the exposition closed in 1905, the money was no longer available to fund her program, but Baldwin lobbied to have it funded by donations and the

Lola Baldwin, 1890. *Oregon Historical Society.*

YWCA. Funds ran out in 1907, and by testifying in front of the city council, Baldwin had it funded once more. Gloria E. Meyers, author of the biography about Baldwin titled *A Municipal Mother*, relates, "She reminded the council that it had recently earmarked $6,000 for the city dog pound and asked for half that annual amount to care for Portland's straying daughters. The council approved the appropriation with the stipulation that she and any assistants pass the civil work service exam for police."

Baldwin was sworn in for police service on April 1, 1908. This made her the area's first policewoman, and perhaps the first in the country, though the title of "first policewoman in the United States" is contested. A retired Drug Enforcement Agency agent, Rick Barrett, researched for years a woman named Marie Owens, who worked for the Chicago Police Department in the 1890s. He concluded that Owens worked as a sergeant, though a historian mixed up her name with another woman and erased Owens's story from the records. Her story is not included with the histories of women in Chicago, and her descendants did not know of her history, according to an article in the *Chicago Tribune*.[61]

Above: A YWCA hat-making class, 1920. *Oregon Historical Society*.

Opposite, top: A typical women's boardinghouse in Portland. This was the boardinghouse of the Portland Women's Union. *Oregon Historical Society*.

Opposite, bottom: The typing pool at a U.S. bank, 1915. *Oregon Historical Society*.

Baldwin concentrated her effort on "the moral and physical welfare of young, single working women," as the Oregon Public Broadcasting film on Baldwin pronounces. The documentary notes that her "preventative policies" influence "policing policies to this day."

Her list of accomplishments is impressive. She helped create the Hillside Industrial School for Girls in Salem. Baldwin helped obtain federal funding for the Cedars Venereal Detention Facility for Women in Portland and was an investigator for the U.S. government in interstate prostitution cases while lobbying for laws to protect women and children. Her advocacy lasted beyond her retirement in 1922. She worked on both the Oregon Parole Board and the National Board of Prisons and Prison Labor. Her death in Portland at ninety-seven completed a long life of public service.

One hundred years after she was inducted as a policewoman, the Portland mayor named April 1, 2008, Lola Greene Baldwin Centennial Day.

The history of working women in the state was changing in Lola Baldwin's time. Women had to work, but they wanted to be part of new technology and have opportunity along with their newfound and hard-won ability to vote. The West was in some ways ideal for women in this regard. With fewer societal rules due to the ideals the West provided of a place to make your own way, women could have more choices occasionally.

Lola Baldwin. *Oregon Historical Society.*

During the Depression, women were just as desperate as Dorothea Lange's famous photographs depict in Oregon as in the rest of the country. Farms were crowded with people sent to refugee-type camps for people who could no longer afford to keep their homes.

Happily, as the economy stabilized, the workforce needed bodies as well. As the world edged into World War II, women were needed in Oregon to make up a workforce suddenly bereft of men. The shipyards in particular needed skilled work. Vanport, the country's largest wartime housing development, was a place to be trained and get a good-paying job.

Iona Murphy, who had her photo taken while working on a ship, was one of the more than thirty thousand women who worked in shipyards in Portland, Vanport, and nearby Vancouver, Washington, according to researcher Tania Evenson of the Oregon Historical Society.[62] She and others built tankers, aircraft carriers and merchant marine ships during the war. Pat Koehler, another shipbuilder, writes in her remembrances how she and her friends would buy "leather jackets and plaid flannel shirts from the men's section of [department store] Meier and Frank" to wear with the regulation helmets. The work was at times grueling and at times shocking. Koehler relates seeing a "flash" when a man nearby was working in a cherry-picker and suddenly his forearms were black.[63]

Cranberry pickers at work near Seaside. The coastal area is well suited to the cranberry bogs and is a large contributor to the national cranberry market. *Oregon Historical Society.*

This migrant worker at Klamath Falls was photographed by Dorothea Lange as part of a WPA tour of the United States in 1939. *Library of Congress Prints and Photographs Division, Washington, D.C.*

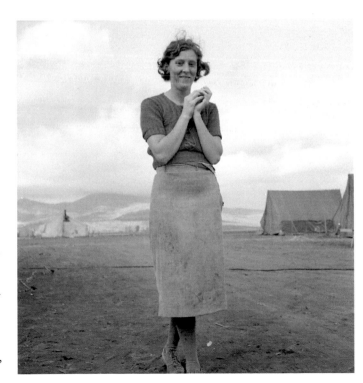

Women at work propaganda poster,
1943. *Oregon Historical Society.*

Women's Land Army, 1944. *Oregon
Historical Society.*

Agriculture needed women too. The agricultural backbone of Oregon had to be kept upright. An Oregon State Archives exhibit says:

Among other things, this labor shortage spurred farmers to accelerate the use of mechanical equipment. It also contributed to the growing consolidation of small farms into larger, more commercial concerns, a trend that would continue after the war. But the most immediate result of the lack of farm workers was a raft of new federal farm labor programs that gave city and town dwellers the chance to bring in the crop for the war cause and get a taste of farm life in the process.[64]

It was not just celebrated women but also everyday women who joined in. They preserved the agricultural integrity of the state during the war and in some cases were able to keep their jobs in canneries, fisheries or farms. Organizations like the Women's Land Army provided day labor to farmers or provided training for year-round employment for women in ways that had not been available before.

Chapter 8

EDUCATE US

CORNELIA MARVIN PIERCE, MARY ISOM AND FRANCES FULLER VICTOR

From the tradition of the pioneer schoolhouse, Oregon has a history of providing education to its residents. Cornelia Marvin Pierce's aim was to bring education to everyone and make books accessible to all Oregon citizens.

When she dedicated the State Library Building in 1939, Pierce wrote the following:

> *I do recall most vividly indeed those beginnings in August, 1905, when I arrived in Salem as Secretary of the Oregon Library Commission, which had neither books, quarters, traditions, nor financial support beyond the state appropriation of $1,200 a year for all expenses. The field was clear before me. It was the great privilege of my life to have placed in my hand the beginning and shaping of the new library venture in Oregon. Formulating policies, securing financial support from the Legislature, planning legislation for extension of library service through public and county libraries, and finally winning the name of Oregon State Library for the institution filled over 25 busy years of my life.*[65]

Originally from Monticello, Iowa, Pierce entered one of four library training programs that existed in the country, the Armor Institute of Technology, in 1894. She finished school and worked in other library facilities in Wisconsin before moving to Oregon. Traveling to all corners of the state in a wagon, she preached public libraries to any who would listen. By her side were "speakers from the office of J.H. Ackerman, Oregon State School Superintendent," and they found that most small communities,

though receptive, could not afford libraries. She designed a concept for a traveling library and sought funding from the state to purchase fifty books with which to start the program. She said later of the program:

> *Excellent subscription libraries in Ashland, Astoria, and elsewhere, after much persuasion, were made free libraries. Books began to flow into the little schoolhouses too remote to be reached by public libraries. Sets of encyclopedias and reference books were clipped (for lending in sections) in order that the benefits of books collected in Salem might reach beyond the walls which housed them and be put in hands stretched out from the far corners of the state.*

The Oregon Library Commission, of which she was the head, became the State Library in 1913. She continued her work of assisting "communities

Cornelia Marvin Pierce, circa 1930. *Oregon Historical Society.*

in organizing, opening, and securing tax funding for libraries and provided direct services from its offices in Salem." Oregon's literary landscape changed because of Pierce's fierce fight to bring books to the people. When she started work in the state in 1905, there were three public libraries; by 1928, there were eighty-two.

She became the wife of Oregon governor Walter M. Pierce in 1925. Her work would continue at the State Board of Higher Education, where she served on the board from 1931 to 1935.

A co-worker, Mary Francis Isom, worked to transform the library system through the Library System of Portland. Isom, about whom little is known as far as her early life, was "an important leader of a cultural institution with a long service to Portland's elite, as it was transformed into a tax supported free public institution." Born in 1865 to an army sergeant and his wife in Tennessee, she attended Wellesley College for a year and then returned home.

Isom attended Pratt upon her father's death and shortly after she graduated was chosen for a job in Portland for which she was responsible for cataloguing a large donation of books from a wealthy donor who wished them to be accessible to the public. The period between September 1900 and May 1902 saw a large change in library funding when the Oregon legislature passed a succession of levies to support library funding. At the same time, Isom's star was rising quickly, and upon the retirement of the head librarian, she became the head of the Library System of Portland.

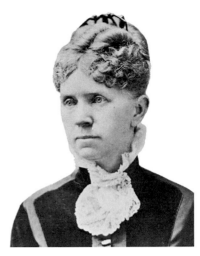

Frances Fuller Victor. *Oregon Historical Society*.

Membership in the system grew as the population expanded. People using the Library System of Portland, which opened its doors in 1893, "went from 5,750 in 1901 to 228,918 in 1903," according to researcher Cheryl Gunseman in an article for the journal *Library Trends* in the spring of 2004.[66] Isom was wed to her job, having come to Oregon at thirty-seven, unmarried and financially stable. She would adopt a daughter and volunteer, travel and perform civic service though other organizations until her death from cancer in 1920. Letters suggest that her friend Pierce, with whom she fought over many years to bring books to the populace of Oregon, was with her at the end of her life in the little cottage where she had retired by the ocean.

An eminent historian, Francis Fuller Victor, can also be counted in the teaching category. She contributed to and compiled the book *History of Oregon* over a period of thirteen years from firsthand pioneer accounts by Oliver Applegate, Matthew Deady and Joseph Meek. The book was later published while she was contracted to work for historian Hubert Howe Bancroft, and he retains the title, but she authored large portions of his work.

Victor was born in New York in 1826. Educated there and in Ohio and Pennsylvania, she showed an early aptitude for writing. Reports have her writing her first poem by nine. In 1848, she moved back to New York, where she and her sister wrote for the Morris and Willis *Home Journal* and local periodicals. She also published her first novel, *Anizetta, the Guajira; or, The Creole of Cuba*, that year.

In 1851, with ailing parents, she went to Michigan to help take care of her family members. She married briefly and settled with her husband but left him and lived with her sister once more. Remarried to her sister's husband's brother, she left for Oregon in 1864. The move signaled a shift in her subject from a novelistic and fictional bent to a historical one.

From 1864 to 1867, her research into the history of Oregon produced the books *Rivers of the West, All Over Oregon and Washington* and *The New Penelope*. Hubert Howe Bancroft hired her to work for him based on the strong writing and research evidenced in these books. He gave Victor "only brief mention in the acknowledgements," and eventually she parted with him in 1890.[67]

THE ENTERTAINERS

BEVERLY CLEARY AND URSULA LE GUIN

Two spots on the Portland Walk of the Heroines are occupied by world-renowned authors and favored native daughters Beverly Cleary and Ursula Le Guin.

A book by Beverly Cleary is almost required reading for American grade schools. She is the author of over thirty books for children and young adults and has received numerous awards. Ilene Cooper wrote in *Booklist*, "When it comes to writing books kids love, nobody does it better."[68] She was born in 1916 in McMinnville, Oregon. What is so interesting about Cleary is that the writer herself struggled in childhood to read.

From her birth on April 12, 1916, to about age six, the family lived in Yamhill, a miniscule town halfway between Portland and the coast. The town was too small to have its own library, so Beverly's mother instead arranged to have books sent to them via the state library system, and Cleary learned to love books. When they moved to Portland, the new reading teacher selected Cleary to be in the low reading group. She had a hard time with that first-grade teacher and was also frequently ill, which compounded her difficulty with reading. That changed in second grade. Cleary was placed with a more sympathetic teacher, and then in third grade her love of books returned. Her biographical statement reads, "By the third grade she had conquered reading and spent much of her childhood either with books or on her way to and from the public library."

The experience with the library, and with the encouraging librarian, made her believe she could write books for children herself. Her college years

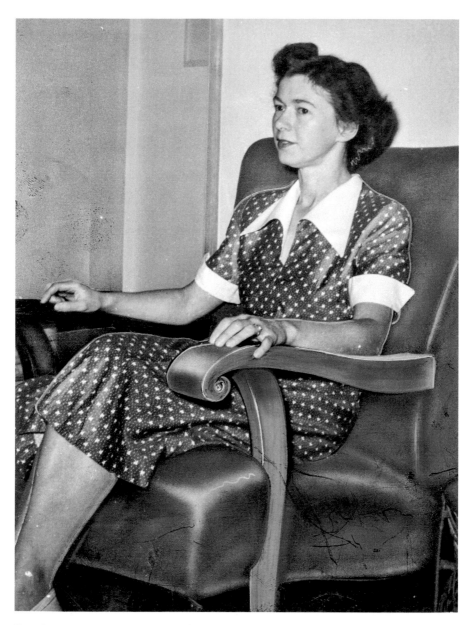

Beverly Cleary, 1954. *Oregon Historical Society.*

were spent at Chaffey College in California, the University of California–Berkeley and the University of Washington–Seattle, where she studied library science. She met her husband, Clarence Cleary, while at Berkeley, and the two married in 1940.

Beverly Cleary, 1971. *Oregon Historical Society.*

Her career as a librarian would inform her writing. While at the checkout desk, she heard kids asking for books about kids like themselves. Her stories of real, modern children would be told in her books, from *Ramona Quimby, Age 8* to those about Henry Huggins, Ellen Tebbits and others. Her later series *Ralph S. Mouse* was popular, and *Dear Mr. Henshaw* won the 1984 John Newbery Medal.

Cleary's books won numerous other awards. In 2003, she was awarded the National Medal of Art from the National Endowment for the Arts. *Ramona and Her Father* and *Ramona Quimby, Age 8* were Newbery Honor books. She won the Laura Ingalls Wilder Award in 1975, the Catholic Library Association's Regina Medal of 1980 and many others. In 2000, the United States Congress named her a "Living Legend."

Today, you can visit a sculpture garden in Portland with many of her characters realized in bronze. Or you can visit the former Hollyrood-Fenwood school, renamed the Beverly Cleary School in 2008, which she once attended. The Multnomah County Library even commissioned a map of Henry Huggins's Klickitat Street, which you can see as you come in on the lobby wall.

Writers like Neil Gaiman and Salman Rushdie count Oregon author Ursula Le Guin as an influence. A National Book Award Foundation Medal winner, she has written futuristic, alternative science fiction that has changed the rules and reinvented the genre, "some of which has been in print for over forty years."

Newsweek wrote of her: "She wields her pen with a moral and psychological sophistication rarely seen…and while science fiction techniques often buttress her stories they rarely take them over. What she really does is write fables: splendidly intricate and hugely imaginative tales about such mundane concerns as life, death, love, and sex."[69]

Le Guin is very private in her personal life. She was born Ursula Kroeber to famous anthropologist Alfred L. Kroeber and writer Theodora Kroeber, author of *Ishi* and *The Inland Whale*. Her college years were spent at Radcliff

College and Columbia University, and she won a Fulbright scholarship to study in France. She and Charles Le Guin married in 1963 in France and then returned to the United States, where the first two of their kids were born in Idaho. The third was born after they moved to Portland. Of writing while having small children, she said on her website, "It was tough trying to keep writing while bringing up three kids, but my husband was totally in it with me, and so it worked out fine. Le Guins' Rule: One person cannot do two fulltime jobs, but two persons can do three fulltime jobs—if they honestly share the work."

Though retired from teaching now, she has lectured all over the world, and now her appearances are based on the West Coast of the United States. She has written "seven books of poetry, twenty-two novels, over a hundred short stories (collected in eleven volumes), four collections of essays, twelve books for children, and four volumes of translation." Her best-known works are the *Earthsea Chronicles*, an Iron Age society fantasy in thirteen short stories

Ursula Le Guin. *Oregon Historical Society.*

and five novels, each of which received a literary award. Her Hainish Science Fiction series, in eight books, won five national awards, including the Hugo, Nebula, Locus and Endeavour Awards.

The *Library Journal* writes, "Her worlds are haunting psychological visions molded with firm artistry." But not many of her works have been adapted for film or television. She retains the right to produce them but was convinced to allow Japanese filmmaker Hayao Miyazaki to film *Tales from Earthsea* as an animated movie in 2006.

Themes in her work include environmentalism in both poetry and prose. She also explores her own Taoist and anarchist ideas in her work, notably in *The Dispossessed*. The idea of anarchism, to her, "is a necessary ideal at the

very least. It is an ideal without which we couldn't go on. If you are asking me is anarchism at this point a practical movement, well, then you get in the question of where you try to do it and who's living on your boundary?"

Le Guin continues to push boundaries and craft lyrical work for children, adults and scholars. An excerpt from her work *Cheek by Jowl: Talks and Essays on Why Fantasy Matters* puts it well:

> *In reinventing the world of intense, unreproducible, local knowledge, seemingly by a denial or evasion of current reality, fantasists are perhaps trying to assert and explore a larger reality than we now allow ourselves. They are trying to restore the sense—to regain the knowledge—that there is somewhere else, anywhere else, where other people may live another kind of life.*
>
> *The literature of imagination, even when tragic, is reassuring, not necessarily in the sense of offering nostalgic comfort, but because it offers a world large enough to contain alternatives and therefore offers hope.*[70]

STRENGTH IN OUR HANDS

BETHENIA OWENS-ADAIR

S he is a woman of contradictory terms, but Bethenia Owens-Adair was an Oregon woman of repute and certainly a "woman who dared." Her status as a woman did not keep her from becoming a doctor in 1881, decidedly a hard time to be both female and with ambition, and she took care of her son George as a single mother. Her later views helped advance the suffragist movement. Still later, her work on eugenics took a darker turn.

Bethenia was born to Sarah Damron and Thomas Owens and named Bethenia Angelique Owens in Van Buren County, Missouri, on May 4, 1840. She was the third of the couple's eleven children. Her family left Independence on the Oregon Trail to the West as part of the Great Migration of 1843. The wagon train Thomas chose was one of great importance: the Applegate Trail wagon train of 1843.[71]

As part of the Great Migration, the family became part of the estimated seven hundred to one thousand people to migrate across the country that year. When the group reached Fort Hall, an outpost in eastern Oregon Territory, the consensus was that the group should abandon their goods and wagons and go by pack mule. A faction did not agree, and the group was led partway by Dr. Marcus Whitman, later to come to fame as director of the Whitman School and victim of the Whitman Massacre. The chief difference in his scheme was that instead of taking the wagons apart, they would clear and build roads when necessary. They did so, building a road around the Blue Mountains, but were forced to float the wagons down the Columbia to get around Mount Hood. Three members of the Applegate family, good friends to the Owens

family on the train, drowned. Jesse Applegate, the livestock team leader of the party, vowed to create an easier route.

The Applegate Trail was an alternative to the Oregon Trail that was rumored to be an easier and less arduous route to the Willamette Valley. It had its own difficulty, but the group including Jesse Applegate blazed the trail in 1846, and by 1853, over 3,500 people had taken the route. He came to have his own trail and area of Oregon as his namesake, including several roads, schools and a historic area, though current researchers contest the name of the trail. Applegate would later figure in Bethenia's life as a notable who vouched for her entry to medical school.

Bethenia Owens-Adair. *Oregon Historical Society.*

The Owens family ended up in Clatsop Plains, Oregon, south of Astoria at the upper tip of the Oregon coast. In 1848, Thomas and others built a ship to take goods to San Francisco and apparently did very well, selling all the stock they had on board. The Oregon Pioneer website said that he "arrived in OR with a half dollar and 10 years later had over $20,000 in the bank."

Bethenia was required to do a great deal of helping around the farm as a girl in the pioneer West and was said to be often tending to a sibling, as she was one of twelve children. Her relationships were so tender that her first memory was of younger brother J.L. taking his first steps toward her mother. Bethenia was a self-described tomboy who often wrestled with her brothers and refused to back down from a dare. Part of one of her front teeth was broken off in a wrestling match with J.L. after they had grown older and he had outstripped her in size. It was not repaired until eighteen years later. She was very pleased with the gold front tooth and said that "the rarity of such an artistic piece of work in the mouth added to its attractiveness."

Her life with her brothers and sisters seems to have been loving and humor-filled. Her male siblings bet her at age thirteen that she couldn't carry four bags (or two hundred pounds) of flour. They placed a bag on

each of her shoulders and she maneuvered a bag under each arm to walk through the doorway. Indeed, she said that her greatest regret was that so many doors were closed to her and opportunities denied just because of her sex.

When she was twelve, she developed a crush on the young teacher who was teaching school for a short time in the area. A fun story about Mr. Beaufort, who boarded with the Owens family, goes that he bet "$200.00 and his watch against $100.00 cash and whatever the residents could get together" that he could dig, gather and measure sixty bushels of potatoes in ten hours. The townspeople, thinking of the schoolmaster's soft hands, took the bet, except Bethenia's father. The schoolteacher gathered those sixty bushels using a hoe cut down to half size and astonished the farmers, who used a full-size hoe, and the natives, who dug them up on hands and knees. Bethenia was impressed by that last lesson the teacher taught the residents. She would later go on to use the latest tools in medicine despite common knowledge of the time.

Mrs. McCrary, a mother-like figure to Bethenia, taught her to sew, embroider and crochet in her visits. The neighbor was a model to her in behavior, praising her for cleanliness and tidiness, and a refuge she could escape to for peace and quiet from her family.

The family later moved to the Umpqua Valley and a larger place for them to live and run their ever-larger stock of animals. They moved to Roseburg, Oregon, with Bethenia and brother Flem driving the cattle south for the journey. Her father said they were "worth more than any two men he could hire."

They settled and built a house in Roseburg. One of Thomas Owens's former farmhands from Clatsop had moved to the Roseburg area with his own family previously. He visited and asked for Bethenia's hand in marriage when she was thirteen and he was in his mid-twenties. It being customary at the time to marry young, her parents agreed. Bethenia and Legrand Henderson Hill were married on the day she turned fourteen, and they went to live on an adjacent claim to her parents' home, four miles distant. The "home" Legrand built her was little more than a house built into the hillside with a dirt floor and windows, and the furnishings were paid for when she was asked by her father to pick what she liked from his store. They had a gopher problem, and as Legrand was in no hurry to put in the flooring, water would gush through the holes when it rained. It was so close to the hillside that Bethenia writes of moles, gophers and small animals dropping frequently on the roof.

They left soon thereafter, about a year later, for a claim in Jacksonville, Oregon, following the gold rush there. From there, Legrand had a notion

to follow gold down to Yreka, California. This would require a wagon train much like the one Bethenia had traveled on as a child, fraught with muddy roads and cattle crossings, natives and losses, though on a much smaller scale. Bethenia endured much the same kind of behavior from her husband both on the trek down to California and once they got there. Despite having a small stake, Legrand continued to while away his time, working at one odd job and another, instead of settling into a career. Bethenia had the company of Legrand's Aunt Kitty, who was her chief friend and confidante, continuing the tradition of Bethenia's female allies. Kitty took them into her home, seeing as Legrand was in no hurry to set them up in a house of their own, and taught Bethenia much of the work she did as a widow taking care of her own homestead.

The rocky marriage was over by 1859, five years later. In the interim, they'd had a son, George. Legrand, with his somewhat shifty work history, was caught trying to sell the small property in Yreka when Thomas came to visit after Bethenia contracted typhoid fever. Legrand was summarily relieved of George and Bethenia's care when her father took them to live with him in Roseburg, Oregon. Bethenia had great sorrow when she thought about Aunt Kitty, who had given her so much love and affection, even to the point of dressing her in clothing she'd had made for her and showing her how to fashion clothing and hats to suit her better.

After her convalescence, Bethenia tried to make things right between herself and her husband and was indeed asked by her father to do so. It may have been hard to resist her father's request, especially due to the mores of the time. The actions of Legrand did not change, however. Any chance for reconciliation was lost when Legrand was violent with both Bethenia and George, striking her more than once and throwing baby George on the bed. She came back to her parents' home then, though she worked hard to pay her own way. Nothing more is heard of Legrand, and it is hard not to wonder whether he disappeared due to Bethenia's strong will, which is apparent, or Thomas's reputation and status in the community. In her autobiography, Owens-Adair said that even as far back as her father's youth as a sheriff's deputy in Kentucky, "Thomas Owens [was] not afraid of man or devil."

Bethenia had a great deal of responsibility. Besides having care of George, she divorced Legrand in 1859. She did it in spite of the stain a divorce would be on her reputation at that time. Later in her life, she would be called out when her sister's mother-in-law disapproved of her divorce and questioned the circumstances. Bethenia replied, "Because he whipped my baby unmercifully, and struck and choked me—and I was never born to be struck by mortal man!"

The woman told Bethenia she was disobeying the Holy Bible, but Bethenia did not agree. The mother-in-law later begged for Bethenia's forgiveness when her own daughter was poorly treated and nearly strangled by her husband. One of the things Bethenia was pleased about after her divorce was the fact that she was able to retain her father's name, and she vowed to never lose it again. She would keep "Owens" until her death.

The realization that she needed to take care of both herself and George, as a single parent, may have prompted her to feel the need to be educated. Determined to be independent, she attended school alongside George when she was done with her chores in the late morning. Her evenings were taken up with studying and mending. She was impressed by suffragist Abigail Scott Duniway's remarks in her newspaper about the deplorable conditions of the Chinese women who were employed as laundresses and seamstresses at the time, and she found work doing these tasks herself to build up some money for her and her son. A story is told by Cara Munson, daughter of the chairman of the school board, about Bethenia being able to pass the teacher's exam merely by spelling the word "baker," due to the chairman's sympathy toward her and her work ethic. Her studies finished, she supported herself and George with teaching and household work until a brother-in-law encouraged her to take up millinery work in 1867.

She worked as a milliner selling hats in Roseburg until a woman with more experience moved to town to compete for the business. She had the training of Mrs. McCrary and the advice provided when she was in Yreka from Legrand's Aunt Kelly to rely on as a seamstress. Perhaps with the assistance of her father's import of goods to San Francisco, she repaired to that city for training.

Bethenia had become fascinated with the women's suffrage movement. It's interesting to speculate whether she could realize the impact she might have on her community and her state. While in Roseburg, she wrote articles supporting the cause for the Roseburg newspapers and the *New Northwest*, a feminist newspaper published in Portland by Abigail Scott Duniway. She appears to have had quite the status in that newspaper.

While in San Francisco, she became acquainted with people in the International Organization of Good Templars (IOGT), a temperance organization designed to help people live free of drugs and alcohol. She rose high in the organization and corresponded with its members regularly. She also met Susan B. Anthony at that time and helped organize her 1871 Roseburg visit. Working with other suffragists like Abigail Scott Duniway once she was home led to writing for Scott's newspaper and a strong friendship.

Leaving George with Abigail Scott Duniway, Bethenia traveled to join the Eclectic School of Medicine in Philadelphia. She recounts an amusing story in her autobiography when she was invited to sit in on an autopsy. The doctors, affronted at her presence as the autopsy was on a male's genital organs, dared her to leave. She asked for a vote, stating that she had been invited and that if a man was allowed to autopsy a female, why was she not allowed to do the same for a male? The vote passed by one attending physician, who gave her the scalpel and allowed her to do the autopsy. Upon leaving the room, she found that word had spread, and people were lining the streets to get a glimpse of the woman who dared defy the male doctors.

She practiced in Roseburg, Yakima and Portland. She championed the care of women and children and wrote of attending births and deaths. When her son, George, became a doctor as well and moved away to Willamette University, she adopted Mattie, a girl whose mother had died in her offices. She helped her sister and son go to school and set up a brother as a pharmacist. Her greatest desire was to have further medical training. She left in 1878. Armed with letters from Jesse Applegate (head of the wagon train she had traveled in when she first came to Oregon), U.S. senators, professors and doctors, she attempted to get into Jefferson Medical School. She was denied but was encouraged to go to the University of Michigan School of Medicine instead. It was a "mixed" school. She studied up to ten hours per day, rising at 4:00 a.m., even throughout vacations, and two years later, she received her medical degree in Ann Arbor. She and her son, by then a doctor himself, took her long-desired trip to Europe with what she had left from the sale of her milliner's shop after her educational expenses.

The September 8, 1881 issue of the *New Northwest* remarks on her return to Oregon: "Dr. Owens has resumed her practice in the city after three years' absence, during which she gained much practical experience and information." She came home with $200 of the more than $8,000 she'd started with and found rooms with a friend in short notice. A male doctor friend who was retiring gave her his medical office supplies for $1, saying she would be making well over $800 per month before long. It was prophetic. She treated hundreds of patients. Several years later, who should come to her practice, sick and virtually penniless, but her rival in Roseburg, the milliner who had been her adversary long before. Bethenia wrote that she paid for the woman's care herself and even transported her in her carriage. Her competition had been the thing that goaded Bethenia on to her current success, and she could not deny her.

When she was done with her own schooling, Mattie came to live with Bethenia. Shortly thereafter, as Oregon was preparing to sign the Women's Suffrage Amendment, she came to the state capital and found an old family friend from Kentucky on the list of people testifying. She drove to the hotel where he was staying and met her friend and some fellow Kentucky pioneers, Colonel Adair and his brothers. She married Colonel John Adair on June 28, 1884, when she was forty-four. Bethenia added his name to her father's. Now she signed her name Dr. B. Owens-Adair. She became pregnant but lost the little girl three days after its birth. They adopted two other children.

Dr. Owens-Adair continued to practice and prosper. She entered postgraduate studies at the Chicago Clinical School in 1903 and retired from active practice in 1905, when she was sixty-five years old. Also in 1905, she and her husband were passengers on a perilous steamship journey on the *Roanoke* from San Francisco to Astoria that resulted in the loss of the ship's rudder. The voyage warranted its own chapter in her life story and apparently was very moving. A huge storm had the entire ship afraid for many days until, as she writes, it finally broke: "On Thanksgiving morning, the sun shone out like the approving smile of God above us; and warmed us back to renewed life and hope."[72] The boat landed in Eureka, California, and Bethenia had another experience with violence when she and her husband intervened as a woman was being beaten and kidnapped. She determined that California was bad for her health and went home to Oregon.

She worked for the temperance union, often writing to the newspapers of the time extolling the virtues of abstaining from alcohol. She joined the Woman's Christian Temperance Union. With her scientific work, she attempted to connect the desire for alcohol to a genetic component. Similarly, mental illnesses were attributed to a genetic cause. In 1910, she published her tract on the eradication of disease through sterilization, titled "Human Sterilization," and used it as the basis for her famous Sterilization Bill, which she lobbied for as early as 1907 and was passed in 1909. The bill was vetoed by the governor, but Owens-Adair continued to lobby for it until it finally passed in 1923 in Oregon. The law made sterilizing "feeble-minded," homosexuals, epileptics, "moral degenerates" and criminals legal. The sterilization practice remained legal to "calm down" patients in mental hospitals or as a punishment until 1967. The law was on the books until it was ultimately eliminated in 1984. Oregon's State Insane Asylum, later known as the Oregon State Hospital, was the basis for the mental ward written about by one-time worker Ken Kesey in his novel *One Flew Over the Cuckoo's Nest*.[73]

Though these ideas seem repugnant today, at the time, she had the latest scientific advances at her fingertips, and her methods were common to the social mores of the era. She was supported by several people mentioned in this book, including Cornelia Marvin Pierce and her husband, Governor Pierce. In her tract, she writes:

> *You know, doctor, as well as I do that hysteria and insanity are often due to diseased reproductive organs. Think of those loathsome victims of an unnamable vice under your charge. It would be nothing less than common humanity to relieve them of the source of their curse and destruction by a simple surgical method that might give them a chance to recover their reason.*[74]

John Adair, her adored husband, died in 1915. She continued to care for the causes she believed in by both writing about them and appearing in person to support them. Her belief in temperance, women's suffrage and the evilness of bringing insanity into the world shaped our state. Her autobiography states her intent to leave her mark on the world: "Through the story of my life, and the few selections from my earliest and later writings…I have endeavored to show how the pioneer women labored and struggled to gain an entrance into the various avenues of industry, and to make it respectable to earn her honest bread by the side of her brother, man."[75]

EERIE APPEAL

OPAL WHITELEY

O pal Whiteley was a "Peter Pan" before the term was coined or a later-day "Alice in Wonderland." She spent over fifty years institutionalized for schizophrenia and died, destitute, in a hospital in England, far from the land she professed to love in her writing. The modern take by writer and mental health counselor Stephan Williamson is that she may actually have had autism or Asperger's syndrome in addition to or instead of schizophrenia.[76] But at one time, Opal Whiteley, her writing and her fey, charming personality captivated a country and the literary world through her personal story, her love of animals and the natural world and her serpentine story of her own history. Her story was compelling enough that in 1988 her work earned an American Book Award for *Harvest Song: Collected Essays and Stories*.

It was through her book *The Story of Opal: The Journey of an Understanding Heart*, purportedly written between the ages of five and seven, that Whiteley quickly became world renowned for a time. She then faded into obscurity almost as meteorically as she had ascended.

Opal, who was known by many names, was born in 1897. In her journals, she claimed to have been the true daughter of a prince but at the age of four was spirited away on a ship. She was taken to the United States and placed, in 1904, with the Whiteley family, who lived at the time in the small mining town of Wendling, Oregon, where they had been raising their five children. The Whiteleys were poor, living off the land as best they could. They had recently lost their oldest daughter, who looked a lot like Opal, when they took her into their family. In 1905, the family moved to Cottage

Grove, Oregon, where they lived until they moved to the small community of Walden located just southeast of Cottage Grove about a year later. Her story of the prince has never garnered any proof, and Opal's mother denied the story.

Walden was where Opal began to blossom. It was a town populated by loggers and miners. It was not uncommon for people to work transiently according to what was in season. The countryside was lush and green and hosted old-growth timber, mills, dirt roads and small farms. The Whiteleys moved from one house to another in the area, but they were never far removed from the outdoors, which Opal grew to love.

Elbert Bede, in his book *The Fabulous Opal Whiteley*, gave additional reasons why it was a good fit for Opal: the town "at least held one great stimulus for human growth—a blessed tolerance for individuality. Here if on the one hand she was not particularly noticed or extolled, on the other hand her development, however willy-nilly it might trend, did not alienate her as queer."

Opal talked very little about her home life in her journals. The veiled references to what, in today's society, would be considered child abuse were unusual in a time when "telling tales out of school" or "airing dirty laundry" were unheard of and controversial. Opal's writing style was odd and the syntax was badly garbled, as in the following quote:

> *By-and-by when the washing part was done, then the mamma went to the grandma's house to get some soap. When she went away she did say she wished she didn't have to bother with carrying water to scrub the floor. She doesn't. While she has been gone a good while, I have plenty of water on the floor for her to mop it when she gets back. When she did go away, she said to me to wring the clothes out of the wash. There were a lot of clothes in the wash—skirts and aprons and shirts and dresses and clothes that you wear under dresses. Every bit of clothes I took out of the tubs I carried into the kitchen and squeezed all the water out on the kitchen floor. That makes lots of water everywhere—under the cook-table and under the cupboard and under the stove. Why, there is most enough water to mop the three floors, and then some water would be left over. I did feel glad feels because it was so as the mamma did want it.*

Her "mamma" must have switched her afterward, as Opal wrote that "I did have many sore feels."

Opal learned as much as she could about the world around her, often playing outside with imaginary friends who lived in the trees. She spoke

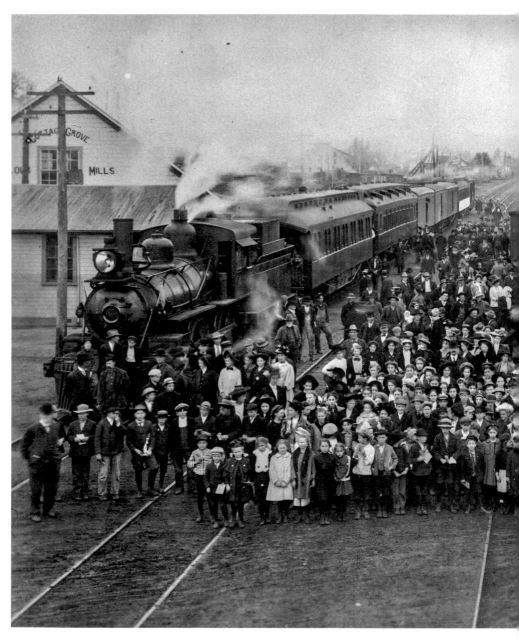

A group of children pose at Cottage Grove Railroad Depot during a visit of the S.P. Farming demonstration train, 1910. *Oregon Historical Society*.

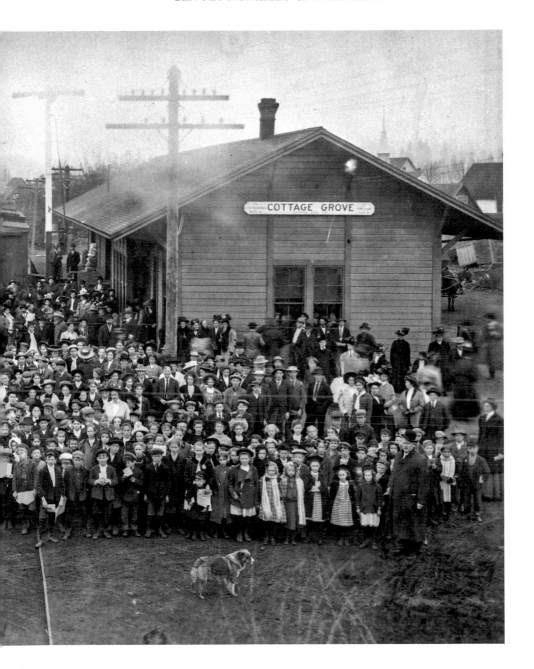

This farmhouse is of the same era as Whiteley's home would have been outside Cottage Grove, Oregon. *Oregon Historical Society.*

to animals and listened to voices that came to her from "the outside." The one-room schoolhouse she attended was perfect for a child with her needs. The format allowed her to advance through the grades at her own fast pace. Because she was a child who purportedly was able to write by the age of three, her education increased rapidly due to her near-photographic memory that aided her both in school and out. Inattention plagued her at times, however, and it caused problems both at school and at home, where she could easily get distracted and/or "help" with the chores, as in the previous quote. Her grandmother stated that when her mother didn't feel up to the task of switching her, she would take over the task.

Opal's first taste of fame may have come at seventeen. In 1915, she was elected state president of the Junior Christian Endeavor group. She set a goal of spreading her message of God's love through the incredible nature and the fairies that she spoke to outdoors throughout the state and spoke to groups as large as three thousand. She taught nature classes as well.

When she visited the University of Oregon at a state conference, the leaders of the college were so impressed with her that officials bent the

Right: A cave near Ashland, 1900. Opal's Junior Christian Endeavor activity would have given her access to other parts of the state and youth group activities like this one *Oregon Historical Society*.

Below: Fun at the beach in the early 1900s. *Oregon Historical Society*.

rules to get her in while she was still in high school. She had hoped for a full scholarship but was awarded somewhat less. With help and financial assistance from others, she was able to live in a small house, which she filled with "16,000 specimens of rocks, plants, butterflies, and insects," as Bede reports. She had her photo taken in many costumes for the newspapers in various outfits that filled the "romantic" notions of the day such as diaphanous garments, Native American–esque outfits and accessories of flora and fauna. She learned about geology, biology, botany and astrology with a fervor that caused her to sit in the library for days at a time, reading.

Her strange and mystic ways helped build the Opal Whiteley legend. *New Yorker* reporter Michelle Dean, in her article "Opal Whiteley's Riddles," has this account: "The wife of the president of the university told people that she had once come upon Opal crouched on the ground, singing what seemed to be hymns, to some earthworms."

After about two years, her enthusiasm for the University of Oregon seems to have waned. She was gifted a large sum of money by a woman and decided to go to Hollywood to try her luck there in the film industry or to find a way to publish a nature book of her own writing. She found people willing to help her, but a few weeks of daily calling at film studios looking for work convinced her to stop. She continued to seek out famous stars and notables of Los Angeles and soon had set up nature classes for children.

Work began on her first book, *The Fairyland Around Us*. It was illustrated by Whiteley and some photographs she had obtained and contained quotes from other naturalists as well as parts of the speeches she wrote about nature for her talks. All her work and funds went into the production, even to the point where she would eat less. She made her way to Boston in 1919. The tiny, dark-haired girl must have made quite a picture, showing up at the offices of the *Atlantic Monthly* with her hand-drawn and lettered, fine leather-bound book in her hand.

Certainly an impression was made on the man she visited there. Editor Ellery Sedgewick declined the offer of *The Fairyland Around Us*. He asked her, as Bede said, about her life, and upon her word-pictures asked about any other books she may have written. Upon discovery of a journal, he was elated. Her famed journal was supposed to have been written as a small child of six or seven and pieced together from her boxes of scraps written on small pieces of waste paper. It was in scraps because her foster sister was supposed to have torn them up in a fit of jealousy or anger when the journal was taken from its hiding place in the middle of the woods where the family lived. The boxes were with the rest of her things in Los Angeles.

Sedgewick arranged for the boxes to be brought to Boston. He gave Whiteley a comfortable set of rooms in his mother-in-law's home, where she lived in more luxury than she probably ever had. There she pieced together the scraps of her journal, pieces of butcher paper and other papers drawn in block letters in crayon. There is no punctuation, spelling or spacing, and upon viewing one of the reconstructed pages, it does look like the work of a child. It was billed as the diary and account of a child's years in a logging camp in Oregon.

It was printed in installments in the *Atlantic Monthly* starting in March 1920. The diarist and her work became a sensation. She attracted the attention of an English lord, Lord Grey, with whom she shared an interest in nature. Publications like the *Christian Science Monitor* and the *London Outlook* took note of her work. She was seen as a miracle, a genius. The *Atlantic*'s circulation soared. Later that year, the diary was published in book form as *The Story of Opal*.

Some of the descriptions Whiteley used are lyrical. It is small wonder that her claim they were written as a young child is questioned. She describes the felling of a treasured tree named Michael Angelo Sanzio Raphael:

> *All the woods seemed a still sound except the pain-sound of the saw. It seemed like a little voice was calling from the cliffs. And then it was many voices. They were all little voices calling as one silver voice come together.*

Piecing together Opal Whiteley's journal. *New York Library.*

*The saw—it didn't stop—it went on sawing. Then I did have thinks the
silver voice was calling to the soul of the big fir tree. The saw did stop.
There was a stillness. There was a queer sad sound. The big tree did
quiver. It did sway. It crashed to the earth.*

She wrote about her simple life with beauty, with descriptions like saying
a slow wind "wears a silk robe today." Her woodland companions all had
names and distinct personalities. She talked about her home life when she
watched a younger sibling. She made observations on neighbors: "And all
her plumpness did fill the grey dress she was wearing." Her wry humor
suffused the portrayal of her reality: "Bye and bye that flour-sack is going
to evolute into an underskirt for me." And she talked about being switched:
"Now I have sore feels and I think it would be nice to have a cushion to set
on." It is charming, if at times treacly sweet to a modern, more cynical sense.

Back home in Cottage Grove, the residents and town were experiencing
a bit of fame as well. Her family was cast under a microscope and was
very unhappy. Mrs. Whiteley, "the mamma," had died three years prior to
publication. Opal's claim of not being a natural child of the Whiteley family
was contested. Meanwhile, Whiteley was traveling around the world. Parts
of her diary were described in French terms, while she claimed to have no
knowledge of the language. Photographs were found that show how much
she resembled "the mamma" and her other relatives, including her sister,
whom she looked very much like. That being said, some members of the
family said she was never like them.

Acrostics were found to be present in parts of her book by scholars.
She had described songs she habitually sang, and the initials of each
word added up to the name of the French man she claimed as her "real"
father, whom she also called her "Angel Father," Henri d'Orleans. Other
songs' initials spell out other members of the French royal family. In
the unpublished diary of her later years, there were seemingly accurate
descriptions of French buildings, churches and family heirlooms of the
d'Orleans family. The *Atlantic* investigated Whiteley's story to back up the
faith that Sedgewick had in her. One evening, Whiteley left Boston in a car
and did not return. She was eventually found in England, having taken up
Catholicism at Oxford University.

The strangest part of Whiteley's story came from 1924 to 1929, when she
lived in India as a princess. Her Royal Highness Mademoiselle Francoise
Marie de Bourbon-Orleans lived in the prosperous court of the Maharana
of Udaipur, prince of Rajputana. Dr. Ray Bowen from the University of

Oregon visited Udaipur in 1934 and could find no trace of her, but it was not a surprise, as female members of the royal family did not leave the palace often. Sedgewick, the *Atlantic* editor, had written to the courts when he heard the story. His disbelief was quelled when he received letters with royal seals from the family affirming HRH Mademoiselle Francoise Marie de Bourbon-Orleans' presence in the court.

Her adopted hometown of Cottage Grove had its moment of fame again in 1926 when it was used as the setting for Buster Keaton's *The General*. The silent film is now regarded as one of the funniest films ever made, going as far as number eighteen on the American Film Institute's funniest films list, the highest rating of any film in the silent era. Its climax scene, a train crash over a ravine, required hundreds of extras who were pulled from the locals and the Oregon National Guard. If Opal had come back, she might have been cast as a small part, for the filming took the entire summer of 1926. Locals still tell stories of family members who were involved in the production, and there are Buster Keaton Days each year, with special celebrations and tours of the filming sites every five years.

This train wreck scene from Buster Keaton's *The General* (1926) employed many locals as well as the Oregon National Guard. It re-creates a scene from the Civil War. *Oregon Historical Society*.

Whiteley had evidently found her "grandmother," Henri d'Orleans' mother, while in England and wrote a friend in Oregon that the woman had been looking for her but World War I had prevented her from finding her. The woman may or may not have supported Whiteley in her India trip. She left India, apparently under amiable circumstances, and went to London. Several magazine articles written about India by Whiteley were published. The year 1948 found her in a basement flat where "her neighbors complained about the smell and she was committed" to Napsbury Mental Hospital. She had shock treatments and perhaps a lobotomy there. As discussed earlier in this article, she was thought to have profound schizophrenia. She died in 1992, registered as Francoise D'Orleans. Her gravestone has both that name as well as the name of Opal Whiteley, and it also has the inscription "I Spake as a Child."

So, is the diary accurate? Was she really an adopted princess who went *From a Logging Camp to Princess of India*, as Bede's excellent book about Whiteley is titled? Opinions differ widely. Whole books and dissertations have been written positing theories going both ways. The *Atlantic* editor purportedly kept and tested a scrap of the butcher paper the diary was scrawled on and pronounced it real. A letter written by Portland attorney G. Evert Baker to Elbert Bede in 1920 was printed in the *Cottage Grove Sentinel* in 1967 to support Opal:

> *When I first read of the doubt concerning Opal's parentage a couple of weeks ago, I thought nothing of it, as I assumed members of the family would straighten out this doubt within a short time. But now it appears that they deny Opal was a foster child.*
>
> *After the meeting I went to the Whiteley home and tailed [talked] with Mrs. Whiteley for some time, because Opal had attracted my attention throughout the meeting, and she stood out above all others in the room. Mrs. Whiteley then told me that Opal was an orphan; that the little girl was not her won [own] daughter. As I now recall it, she said her own daughter had died some years before and she had taken Opal into the family to replace the little daughter whom she had buried. I know she said Opal's father was dead, although I am not absolutely certain concerning the father.*
>
> *It was because I was told Opal was an orphan that I did what I could to assist her, and within two years she became one of the leaders in the Christian Endeavor work in Oregon. Not until the recent publicity given Opal did I realize that the family had not acknowledged Opal as a foster child, although from my acquaintance with Mrs. Whiteley before her death I am certain she tried to keep Opal's parentage secret from her. The first*

*time I met Mrs. Whiteley she sent Opal from the room when she told me
that Opal was not her daughter, and I naturally supposed that Opal knew
nothing about her being an orphan.*[77]

In short, who knows what is true? If she created the diary, she was
unusually bright, creative and determined, precocious beyond the ability of
most children ages five to seven. Another point in her favor is how much
time it would take to create such a façade. That being said, anyone who has
delusions of grandeur can convince herself something is true if she wants to
badly enough, especially in instances of trauma.

There is "evidence," if you read her life story, to support the Asperger's/
autism theory brought forth by Williamson. If you use the Diagnostic and
Statistical Manual of Mental Disorders (DSM-5) definition of Spectrum
Disorders, Whiteley exhibited "highly restricted, fixated interests that are
abnormal in intensity or focus (e.g., strong attachment to or preoccupation
with unusual objects, excessively circumscribed or preservative interest)" and
"deficits in developing, maintaining, and understanding relationships."[78] Her
obsession with listing and collecting animals and specimens could point to
that, as could her laser focus and picture-perfect memory. Her relationships
with her family were scant, to be sure, and there isn't a record of too many
lasting friendships; most associations were like the one with her editor or the
professors at the University of Oregon: blazingly bright but short-lived.

Whiteley had a breakdown in her late teens at an undetermined date
when she did not speak for several months. Her mother—Mrs. Whiteley,
that is—also reportedly spoke of having royal ancestors and could likely have
had a mental illness of some kind. Forensics working backwards in the form
of these observations are by no means a definitive "diagnosis," but given
modern knowledge of mental health and heredity, it is interesting to view
her work through the lens of a spectrum disorder, given the understanding
that we have today about how such disorders work. Bill Gates, of personal
computer fame, is said to have such a condition and he is wildly successful;
it is thought that a variety of historical figures, including Emily Dickinson
and Benjamin Franklin, may have had Asperger's. What if Whiteley had
been able to harness her unusual interests and fixations to such a degree?
Her work in and of the natural world could easily be understood this way.
Supposition has been made that she might have had a disorder called
Synesthesia, a condition where a person experiences "'crossed' responses to
stimuli," according to *Psychology Today*.[79] Stephan H. Williamson wonders in
a piece for the Cottage Grove Historical Society:

People with AS [Asperger's syndrome] *often excel at one intellectual activity, but can have poor social skills. They may be near genius IQ's, and lack common sense. People with AS can have brilliant imaginations and can be very difficult to talk out of a fixed belief. Some researchers wonder if AS should even be classified as a "mental illness." Perhaps people with Asperger's are a necessary addition to the gene pool, since we get so many gifts from them.*

There are several local events and places named in Opal Whiteley's honor. The Opal Center for Arts and Education is a community arts center whose mission is engaging and encouraging local residents with cultural, personal and community connections and events. There is a self-guided Opal Whiteley Tour, with pamphlets available in Cottage Grove stores and museums, to visit thirteen places from her life or things mentioned in her books. A beautiful bronze statue of Opal can be seen in the Cottage Grove Library and Community Center. The statue, donated by South Lane Mental Health, was done by local sculptor Ellen Tykeson and dedicated in 1998. Several books, a television special and a play are dedicated to her story.

Part of the "magic" people refer to with Opal is that we'll never know what was true. She could have been a very shrewd, canny, smart girl who wanted to escape her abject poverty. She could have suffered from being bipolar or schizophrenic or had autism or Asperger's. She could have been a kidnapped princess. There are still a few people alive today in Cottage Grove who knew her and her family, and opinions are as passionate for truth as they are for delusion. What works in her favor is that the communication of the time did not allow for instant fact checks over the Internet. Whatever she was, she was a great self-promoter and a gifted naturalist with a talent for describing a child's interior life. Her spirit comes through as lithe and beautiful in her work as the dragonflies she drew.

NOTES

Chapter 1

1. Wrenn, "Search Results from American Life Histories."
2. Access Genealogy, "Indian Tribes of North America."
3. Indians.org, "Important Role of Native American Women."
4. Quigley, "Federally Recognized Tribes in Oregon."
5. Paul Kane, *Scalp Dance by the Chualpays Indians*, 1856, National Gallery of Canada, Ottawa.
6. King, "Umatilla Women Keep Traditions of Root Digging Alive."
7. Patton, "Celilo Falls, a History Revealed."
8. Native Languages of the Americas, "Oregon Indian Tribes and Languages."
9. Native American Indian Facts, "Northwest Coast American Indian Facts."
10. City of Keizer, "Marie Dorion."
11. Irving, *Astoria*.
12. J., "Marie Dorion."
13. Hopkins, *Life Among the Paiutes*, 1.
14. Ford, "Sarah Winnemucca."
15. Kilcup, "Sarah Winnemucca."
16. Ibid.
17. Rook, "No Justice, No Peace."
18. National Indian Education Association, "Statistics on Native Students."
19. International Council of Thirteen Indigenous Grandmothers, "Grandmother Agnes Baker Pilgrim."
20. Husk, "Eminent Women: Kathryn Jones Harrison."

Chapter 2

21. Slauson and Wrenn, "Early Pioneer Life."
22. Whitman, Letters and Journals of Narcissa Whitman.
23. Slauson and Wrenn, "Early Pioneer Life."
24. Oregon Trail, "Independence Rock."
25. National Oregon/California Trail Center, "A Day on the Trail."
26. Byrd, "Sara Byrd Recalls Her Trip to Oregon."
27. Burgess, "Journals, Diaries, and Letters."
28. Houdek, "Klondike Kate."
29. Eastes, "Return of Rocks Honors Bend's Beloved Kate."

Chapter 3

30. Oregon Blue Book, "1912 Women's Suffrage Proclamation."
31. Shein, "Abigail Scott Duniway."
32. Ibid.
33. Historic Oregon Newspapers, "*The New Northwest.*"
34. Beeton and Scharff, "Abigail Scott Duniway."

Chapter 4

35. Oregon Historical Society, "Julia Ruuttila."
36. Biography.com, "Margaret Sanger."
37. Taylor, "A Wobbly Poet."
38. Brew and Edwards, *Oregon's Main Street.*
39. Polishuk, "Julia Ruuttila."
40. Taylor, "A Wobbly Poet."

Chapter 5

41. Blackpast.org, "Beatrice Morrow Cannady."
42. Portland NAACP, "History."
43. Mangun, "'As Citizens of Portland We Must Protest.'"
44. Griffin, "Walk of Heroines Worth a Visit."
45. Historic Oregon Newspapers, "Morning Oregonian."
46. Oregon Blue Book, "Original 1857 Constitution of Oregon."
47. Gross and Nishihara, "A History of Difference, Power, and Discrimination."
48. Lyon, "Alien Land Laws."
49. Malan, Blake, et al., "Chinese Immigration."
50. Parrish, "WASP on the Web."

51. Ford, "Hazel Lee."

52. Findagrave.com, "Hazel Ying Lee Yim-Quin."

53. Garcia, "Hazel Ying Lee."

54. 514th Air Mobility Wing, "WASPS Receive Congressional Gold Medal."

Chapter 6

55. Umatilla County Courthouse, "Umatilla County History."

56. *East Oregonian*, "Women Tell How They Beat Men."

57. Roberts, *Up the Capitol Steps*.

58. Oregon Historical Society, "Governor Barbara Roberts."

59. Kirchmeier, "My Name Is Barbara."

Chapter 7

60. Oregon Public Broadcasting, "Lola G. Baldwin."

61. Mastony, "Was Chicago Home to the Country's 1st Female Cop?"

62. Evanson, "Iona Murphy at Oregon Shipbuilding Corp., Portland."

63. "Reminiscence: Pat Koehler."

64. Oregon State Archives, "Farm Labor Programs."

Chapter 8

65. Green, "Cornelia Marvin Pierce."

66. Gunselman, "Cornelia Marvin and Frances Mary Isom."

67. City of Portland, "Frances Fuller Victor."

Chapter 9

68. The World of Beverly Clearly, "About Beverly Cleary."

69. "Ursula K. Le Guin: Biographical Sketch."

70. Ibid.

Chapter 10

71. Flora, "Emigrants to Oregon."

72. Loftus, "Woman Surmounted Many Obstacles."

73. Oregon Historical Society, "Bethenia Owens-Adair."

74. Oregon State Hospital, "Suffrage and Sterilization: Dr. Owens-Adair."

75. Owens-Adair, "Dr. Owens-Adair; Some of Her Life Experience."

Chapter 11

76. Williamson, "Opal Whiteley."

77. Bede, *Fabulous Opal Whiteley*.

78. *Diagnostic and Statistical Manual of Mental Disorders: Dsm-iv-tr*, "What Are Autism and Asperger's?"

79. *Psychology Today*, "Synesthesia."

Works Referenced

Abbot, Carl. "Vanport." The Oregon Encyclopedia. www.oregonencyclopedia.org/articles/vanport/#.VedNkHtJeRs.

Access Genealogy. "The Indian Tribes of North America." July 9, 2011. www.accessgenealogy.com/native/indian-tribal-histories-s-tribes.htm.

Beda, Steven C. "More Than a Tea Party." *Pacific Northwest Quarterly* 100, no. 3. (Summer 2009): 134–35. www.jstor.org/stable/40492204.

Bede, Elbert. *Fabulous Opal Whiteley: From a Logging Camp to Princess of India.* Portland, OR: Binfords & Mort, 1954.

Beeton, Beverly, and Virginia Scharff. "Abigail Scott Duniway." Women of the West Museum, 2000. theautry.org/explore/exhibits/suffrage/abigail3_full.html.

"Bethenia Angelique Owens Adair: Pioneer Woman Doctor of the Northwest." *Dameron-Damron Family Newsletter* 33 (Fall 2001).

Biography.com. "Margaret Sanger." September 9, 2015. www.biography.com/people/margaret-sanger-9471186#related-video-gallery.

Blackpast.org. "The Advocate, Portland, Oregon, 1903–1936." www.blackpast.org/aaw/portland-oregon-advocate-1903-1936#sthash.WCNeYDVQ.dpuf.

———. "Beatrice Morrow Cannady and the Struggle for Civil Rights in Oregon, 1912–1936." www.blackpast.org/perspectives/beatrice-morrow-cannady-and-struggle-civil-rights-oregon-1912-1936.

Brew, Jo, and Pat Edwards. *Oregon's Main Street: U.S. Highway 99: "The Folk History."* Lorane, OR: Groundwaters Publishing, 2014.

Burgess, Barbara MacPherson. "Journals, Diaries, and Letters Written by Women on the Oregon Trail 1836–1865." Master's thesis, Kansas State University, 1984. archive.org/stream/journalsdiaries l00burg#page/n0/mode/2up.

Byrd, Sara. "Sara Byrd Recalls Her Trip to Oregon." February 28, 1939. Library of Congress. www.loc.gov/teachers/classroommaterials/presentationsandactivities/presentations/timeline/expref/oregtral/pionlife.html.

Chandler, J.C. *Hidden History of Portland, Oregon.* Charleston, SC: The History Press, 2013, 45.

City of Keizer, Oregon. "Marie Dorion." July 29, 2015. www.keizer.org/Marie-Dorion.

City of Portland, Oregon. "Frances Fuller-Victor." web.archive.org/web/20110609074153/http://www.portlandonline.com/omf/index.CFM?a=149202&c=44053.

Couture, Diane, and Geoffrey Wexler. "Ray Becker Papers, 1919–1970." Archives West. Orbis Cascade Alliance. archiveswest.orbiscascade.org/ark:/80444/xv08227.

Dean, Michelle. "Opal Whiteley's Riddles." *New Yorker,* August 23, 2012. www.newyorker.com/books/page-turner/opal-whiteleys-riddles.

Diagnostic and Statistical Manual of Mental Disorders: Dsm-iv-tr. "What Are Autism and Asperger's?" Washington, D.C.: American Psychiatric Association, 2000.

Eastes, Beau. "Return of Rocks Honors Bend's Beloved Kate." *Bend Bulletin,* August 30, 2015. www.registerguard.com/rg/news/local/33405576-75/return-of-rocks-honors-bends-beloved-kate.html.csp#.VeXrPK5JugM.email.

East Oregonian. "Women Tell How They Beat Men." December 11, 1916, 4. Library of Congress. chroniclingamerica.loc.gov/lccn/sn88086023/1916-12-11/ed-1/seq-4/#date1=1836&index=3&rows=20&words=Laura+Starcher&searchType=basic&sequence=0&state=&date2=1922&proxtext=%22Laura+Starcher%22&y=0&x=0&dateFilterType=yearRange&page=1.

1859 Oregon Magazine. "Eminent Women Breaking Political Boundaries: Barbara Roberts." March 2, 2015. www.1859oregonmagazine.com/eminent-women.

Evanson, Tania Hyatt. "Iona Murphy at Oregon Shipbuilding Corp., Portland." The Oregon History Project, 2002. www.ohs.org/education/oregonhistory/historical_records/dspDocument.cfm?doc_ID=000B9536-CAE3-1E52-BEFF80B05272FE9F.

Findagrave.com. "Hazel Ying Lee Yim-Quin." March 9, 2010. www.findagrave.com/cgi-bin/fg.cgi?page=gr&GRid=49467378.

———. "Lola Greene Baldwin." March 12, 2002. www.findagrave.com/cgi-bin/fg.cgi?page=gr&GRid=6254137.

514th Air Mobility Wing. "WASPS Receive Congressional Gold Medal." March 17, 2010. www.514amw.afrc.af.mil/news/story.asp?id=123195353.

Flora, Stephanie. "Emigrants to Oregon in 1843." 2004. www.oregonpioneers.com.

Ford, Daniel. "Hazel Lee, Chinese-American Heroine." April 2015. www.warbirdforum.com/hazel.htm.

Ford, Victoria. "Sarah Winnemucca." Nevada Women's History Project, 2001. www.unr.edu/nwhp/bios/women/winnemucca.htm.

Garcia, Hector. "Hazel Ying Lee—Fighting for Gender Equality." Fighting for Democracy, 105–12. National Center for the Preservation of Democracy, Library of Congress. July 23, 2015. www.ncdemocracy.org/sites/www.ncdemocracy.org/files/docs/FFD_EducGuide_10_Hazel_0.pdf.

Green, Virginia, comp. "Cornelia Marvin Pierce." Salem Online History. www.salemhistory.net/people/cornelia_marvin_pierce.htm.

Griffin, Anna. "Walk of Heroines Worth a Visit, Additional Names." *Oregonian*, September 19, 2009. www.oregonlive.com/news/oregonian/anna_griffin/index.ssf/2009/09/walk_of_heroines_worth_a_visit.html.

Gross, Joan, and Janet Nishihara. "A History of Difference, Power, and Discrimination at Oregon State University." June 28, 2012. oregonstate.edu/dept/dpd/history-difference-power-and-discrimination-oregon-state-university.

Gunselman, Cheryl. "Cornelia Marvin and Frances Mary Isom: Leaders of Oregon's Library Movement." *Library Trends* (Spring 2004): 877–901. JSTOR. www.ideals.illinois.edu/bitstream/handle/2142/1699/Gunselman877901.pdf.

Historic Oregon Newspapers. "*Morning Oregonian.* (Portland, Or.) 1861–1937, January 14, 1915, Image 18n." oregonnews.uoregon.edu/lccn/sn83025138/1915-01-14/ed-1/seq-18.

———. "*The New Northwest.* (Portland, Or.) 1871–1887. Image 1." August 11, 1871. www.chroniclingamerica.loc.gov/lccn/sn84022673/1871-08-11/ed-1/seq-1.

Hopkins, Sarah Winnemucca. *Life Among the Paiutes: Their Wrongs and Claims.* Boston: G. Putnam and Sons, 1883.

Houdek, Jennifer. "Klondike Kate: Queen of the Yukon, 1876–1957." University of Alaska–Anchorage, 2000–2015. www.litsite.org/index.cfm?section=digitalarchives&page=industry&cat=Mining&viewpost=2&contentid=2713.

Husk, Lee Lewis. "Eminent Women: Kathryn Jones Harrison." *1859 Oregon Magazine* (March 2, 2015). www.1859oregonmagazine.com/eminent-women.

Indians.org. "The Important Role of Native American Women." July 29, 2015. www.indians.org/articles/native-american-women.html.

International Council of Thirteen Indigenous Grandmothers. "Grandmother Agnes Baker Pilgrim." May 20, 2010. www.grandmotherscouncil.org/who-we-are/grandmother-agnes-baker-pilgrim.

Irving, Washington. *Astoria.* Chapter 15. 1836. The Literature Network. www.online-litcrature.com/irving/astoria/15.

J., Dominique. "Marie Dorion." Young and Brave: Girls Changing History. National Women's History Museum and Girls Learn, International, Inc., 2008. www.nwhm.org/html/exhibits/youngandbrave/dorion.html.

Kilcup, Karen. "Sarah Winnemucca (Thocmetony; Paiute) (c. 1844–1891)." *The Heath Anthology of American Literature.* 5th ed. Edited by Paul Lauter, August 2015. college.cengage.com/english/lauter/heath/4e/students/author_pages/late_nineteenth/winnemuccathocmetony_sa.html.

King, Anna. "Umatilla Women Keep Traditions of Root Digging Alive." Oregon Public Broadcasting, July 17, 2012. www.opb.org/news/article/umatilla-women-keep-traditions-root-digging-alive.

Kirchmeier, Mark. "My Name Is Barbara." *Willamette Week*, November 2, 2011. www.wweek.com/portland/article-18158-my_name_is_barbara.html.

Lake, Randall A. "San Francisco County Women Suffrage Association—January 4, 1871." *She Flies with Her Own Wings.* Annenberg School for Communication and Journalism, October 7, 2011. asduniway.org/speeches.

Loftus, David. "Woman Surmounted Many Obstacles to Become a Doctor: Bethenia Owens-Adair Dared Do What Few Women Ever Had." *News-Review*, February 21, 1988.

Lyon, Cherstin. "Alien Land Laws." Densho Encyclopedia. encyclopedia.densho.org/Alien%20 land%20laws.

Malan, Nancy, Kelly Blake et al. "Chinese Immigration and the Chinese in the United States." National Archives. www.archives.gov/research/chinese-americans/guide. html.

Mangun, Kimberly. "'As Citizens of Portland We Must Protest': Beatrice Morrow Cannady and the African American Response to D.W. Griffith's 'Masterpiece.'" *Oregon Historical Quarterly* 107, no. 3 (Fall 2006): 382–409. www.jstor.org/stable/20615659.

———. "Beatrice Morrow Cannady." Oregon Experience. www.opb.org/television/ programs/oregonexperience/segment/beatrice-morrow-cannady/#c.

———. *A Force for Change: Beatrice Morrow Cannady and the Struggle for Civil Rights in Oregon, 1912–1936*. Corvallis: Oregon State University Press, 2010, 19.

Mastony, Collen. "Was Chicago Home to the Country's 1st Female Cop?" *Chicago Tribune*, September 1, 2010. www.articles.chicagotribune.com/2010-09-01/news/ct-met-first-police-woman-20100901_1_female-officer-police-officer-female-cop.

McQuiddy, Steve. "The Fantastic Tale of Opal Whiteley." 1997. Special Collections, University of Oregon Library.

Mortensen, Camilla. "Corvallis Play Area Memorializes Young Boy, Native Peoples." *Eugene Weekly*, August 13, 2015.

Myers, Gloria E. "Lola Greene Baldwin." Oregon Encyclopedia. www.oregonencyclopedia. org/articles/baldwin_lola_1860_1957_/#.Vc5A6MtRHIU.

National Indian Education Association. "Statistics on Native Students." www.niea.org/ Research/Statistics.aspx.

National Oregon/California Trail Center at Montpelier, Idaho. "A Day on the Trail." www. oregontrailcenter.org/HistoricalTrails/ADayOnTheTrail.htm.

Native American Indian Facts. "Northwest Coast American Indian Facts." www.native-american-indian-facts.com/Northwest-Coast-American-Indian-Facts/Northwest-Coast-American-Indian-Facts.shtml.

Native Languages of the Americas. "Oregon Indian Tribes and Languages." www.native-languages.org.

Olson, Kristine. "Kathryn Harrison." Oregon Encyclopedia. oregonencyclopedia.org/ articles/harrison_kathryn_1924_/#.VedQwHtJeRs.

Oregon Blue Book. "1912 Women's Suffrage Proclamation." November 30, 1912. bluebook. state.or.us/state/elections/elections06b.htm.

———. "Original 1857 Constitution of Oregon: Suffrage and Elections." Article II, Number 6, and Amendment 14, Section 1. bluebook.state.or.us/state/constitution/orig/article_II_03.htm.

Oregon Historical Society. "Beatrice Morrow Cannady." The Oregon History Project. www. ohs.org/education/oregonhistory/historical_records/dspDocument.cfm?doc_ID=157052ff-d3dd-1d8b-701b7fabcc173e81.

———. "Bethenia Owens Adair." The Oregon History Project. www.ohs.org/education/ oregonhistory/historical_records/dspDocument.cfm?doc_ID=C08C5AE4-1C23-B9D3-68CDD6F6494E9A5E.

———. "Governor Barbara Roberts." 2008. www.ohs.org/education/focus/governor-barbara-roberts.cfm.

———. "Julia Ruuttila: Education/Focus/A Radical Life." 2008. www.ohs.org/education/focus/a-radical-life.cfm.

Oregon Public Broadcasting. "Lola G. Baldwin." Oregon Experience, April 2, 2015. www.opb.org/television/programs/oregonexperience/segment/lola-g-baldwin-.

Oregon State Archives. "Farm Labor Programs Work to Bring in the Crops." 2008. arcweb.sos.state.or.us/pages/exhibits/ww2/services/farm.htm.

Oregon State Hospital. "Suffrage and Sterilization: Dr. Owens-Adair." www.oshmuseum.org/suffrage-and-sterilization-dr-owens-adair.

The Oregon Trail. "Independence Rock." www.historyglobe.com/ot/indeprock.htm.

Owens-Adair, Bethenia. *Dr. Owens-Adair; Some of Her Life Experience.* N.p.: Mann & Beach Printers, 1906. www.archive.org/details/drowensadairsomOOowen.

———. "Human Sterilization." 1910. Oregon State Library Collections. www.oshmuseum.org/suffrage-and-sterilization-dr-owens-adair.

Parrish, Nancy. "WASP on the Web." wingsacrossamerica.us/wasp.

Patton, Vince. "Celilo Falls, a History Revealed." Oregon Public Broadcasting, November 20, 2008. www.opb.org/news/series/greetings-northwest/celilo-falls-a-history-revealed.

Pearson, Ellen Holmes. "American Indian Women." Teaching History. Roy Rosenzweig Center for History and New Media at George Mason University. www.teachinghistory.org/history-content/ask-a-historian/23931.

Polishuk, Sandy. "Julia Ruuttila." Oregon Encyclopedia, 2015. www.oregonencyclopedia.org/articles/ruuttila_julia_1907_1991_/#.VcyyU8tRHIW.

Portland NAACP. "History." www.portlandnaacp1120.org/history.html.

Psychology Today. "Synesthesia." 2002–15. www.psychologytoday.com/basics/synesthesia.

Quigley, Karen. "Federally Recognized Tribes in Oregon." Home Commission on Indian Services, August 8, 2011. www.oregon.gov/OPRD/HCD/ARCH/docs/oregon_federally_recognized_tribes.pdf.

"Reminiscence: Pat Koehler on the Women Shipbuilders of World War II." *Oregon Historical Quarterly* 91, no. 3 (Fall 1990): 285–91. www.jstor.org/stable/20614321.

Roberts, Barbara. *Up the Capitol Steps: A Woman's March to the Governorship.* Corvallis: Oregon State University Press, 2011.

Rook, Erin. "No Justice, No Peace." *Source Weekly* [Bend, OR], April 29, 2015. www.bendsource.com/bend/no-justice-no-peace/Content?oid=2437919.

Sassi, Kelly, and Anne Gere Ruggles. "Biography of Sarah Winnemucca." Writing on demand for the Common Core State Standards Assessments. 2014. www.heinemann.com/shared/companionResources/E05085/7-6_SarahWinnemuccaBio.pdf.

Shein, Debra. "Abigail Scott Duniway Exhibit Text." University of Oregon, October 6, 2006. library.uoregon.edu/ec/exhibits/feminist-voices/duntext.html.

Slauson, Jean C., and Sara B. Wrenn. "Early Pioneer Life." Library of Congress, Manuscript Division, WPA Federal Writers' Project Collection. Library of Congress, 1939. www.loc.gov/item/wpalh001975/#about-this-item.

Stark, Peter. *Astoria: John Jacob Astor and Thomas Jefferson's Lost Pacific Empire*. New York: HarperCollins, 2014, 108.

Taylor, Stephanie. "A Wobbly Poet." Labor and Grace, June 11, 2013. www.laborandgrace. com/2013/06/11/a-wobbly-poet.

Umatilla County Courthouse. "Umatilla County History." www.co.umatilla.or.us/history. html.

"Ursula K. Le Guin: Biographical Sketch." www.ursulakleguin.com/BiographicalSketch. html.

Wekell, Joan Tuttle. "The Repatriation of the Canoe Stolen by Meriwether Lewis and William Clark in 1805." September 24, 2011. www.chinooknation.org/canoe_returned.html.

Wellons, Sophia. "Oregon's Colored Women's Equal Suffrage League and the 1912 Campaign." Century of Action: Oregon Women Vote, 1912–2012. centuryofaction.org/ index.php/main_site/document_project/oregons_colored_womens_equal_suffrage_ league_and_the_1912_campaign.

Whitman, Narcissa. Letters and Journals of Narcissa Whitman. Archives of the West, July 5, 2015. www.pbs.org/weta/thewest/resources/archives/two/whitman2.htm.

Wikipedia. "Beverly Cleary." en.wikipedia.org/w/index.php?title=Beverly_Cleary&oldid=6 76155489.

———. "Ursula K. Le Guin." en.wikipedia.org/wiki/Ursula_K._Le_Guin.

Williamson, Stephan H. "Opal Whiteley." Cottage Grove Historical Society, 2007–9. www. cottagegrovehistoricalsociety.com/opal_whiteley.html.

The World of Beverly Clearly. "About Beverly Cleary." www.beverlycleary.com/about.aspx.

Wrenn, Sara. "Search Results from American Life Histories: Manuscripts from the Federal Writers' Project, 1936 to 1940." Library of Congress, January 13, 1939. www.loc.gov/ collections/federal-writers-project/?fa=segmentof%3Awpalh2.29091708%2F%7Csubje ct%3Anarratives&st=gallery&sb=shelf-id.

INDEX

About the Author

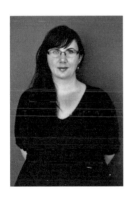

J ennifer Chambers writes about strong women with bold stories. She speaks across the United States about persevering through traumatic brain injury and genetic disorder. Chambers attended the Iowa Writer's Workshop and Duke University. She's active in the Body Love Movement as a speaker and an advocate of self-empowerment.

Chambers is a freelance writer, editor and part owner of Groundwaters Publishing. Her work has been published in numerous national newspapers, magazines and websites. She teaches writing and self-empowerment workshops to people of all ages. As a person with cognitive disability, it's important for her to tell stories about real people living extraordinary lives—and, conversely, tell stories about extraordinary people living ordinary lives in her fiction. She loves playing the ukulele and reading voraciously.

Visit us at
www.historypress.net
...
This title is also available as an e-book